THE SUMI-E
BOOK

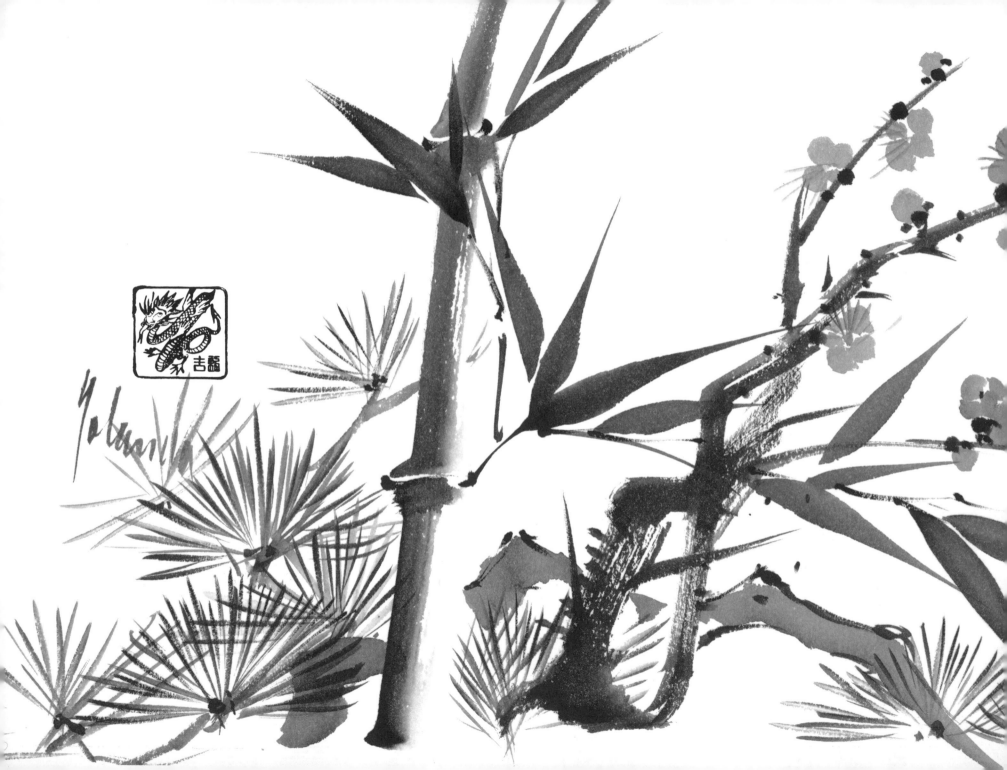

THE SUMI-E BOOK

YOLANDA MAYHALL

WATSON-GUPTILL PUBLICATIONS/NEW YORK

The two haiku poems by Shôha on pages 10 and 97 are
from *The Chime of Windbells: A Year of Japanese Haiku in
English Verse* by Harold Stewart (Rutland, Vt.: Charles E.
Tuttle Co., Inc., 1969), pages 33 and 24. Used by
permission of the publisher.

Edited by Janet Frick
Graphic production by Hector Campbell
Text set in 11-point ITC Galliard

First published in 1989 by Watson-Guptill Publications,
a division of BPI Communications, Inc.,
1515 Broadway, New York, N.Y. 10036

Library of Congress Cataloging-in-Publication Data

Mayhall, Yolanda.
 The sumi-e book / Yolanda Mayhall.
 p. cm.
 Includes index.
 ISBN 0-8230-5022-X
 1. Sumi-e—Technique. I. Title.
ND2462.M46 1989
751.4′252—dc20 89-9182
 CIP

Distributed in the United Kingdom by Phaidon Press Ltd.,
Musterlin House, Jordan Hill Road, Oxford OX2 8DP

Manufactured in the United States of America.

First printing, 1989

8 9 10 11/03 02 01 00

*To my husband Ted,
whose help and support enabled me
to bring this idea to fruition,
and
To my daughters, friends, and students,
each of whom contributed in some special way
to making this book possible.*

Contents

Introduction to Sumi-e 8

The Sumi-e Spirit 9

The Sumi-e Language 10

Sumi-e Materials 11

Painting the Sumi-e Way 14

Yolanda's Ten Rules 15

PART 1
BAMBOO

The Bamboo Brushstrokes 18
The Bamboo Leaf 18
The Bamboo Stalk 23
The Bamboo Node 26

Related Strokes 28
Bird 28
Butterfly 38
Lizard 41
Spider 42
Walking Stick 44
Praying Mantis 45
Ladybug and Grasshopper 46
Mushrooms 47
People 51

PART 2
WILD ORCHID

The Wild Orchid Brushstrokes 54
The Wild Orchid Leaf 54
The Wild Orchid Blossom 56

Related Strokes 60
Fish 60
Water Lily 66

PART 3
CHRYSANTHEMUM

The Chrysanthemum Brushstrokes 72
The Chrysanthemum Flower 72
The Chrysanthemum Stem 76
The Chrysanthemum Leaf 77

Related Strokes 80
Tiger Lily 80
Camellia 83
Poinsettia 86
Magnolia 87
Mouse 88

PART 4
PLUM BRANCH

The Plum Branch Brushstrokes 92
The Plum Blossom 92
The Plum Branch 94

Related Strokes 102
Pine 102
Bonsai 105
Weeping Willow 108
Rocks and Mountains 110

PART 5
EXTRAS YOU WILL ENJOY

More Sumi-e Paintings 114
The Press Stroke 114
Rabbit 117
Squirrel 118
Panda 120
Dragon 122

Glossary 126
Index 128

Introduction to Sumi-e

Sumi-e, a Japanese term meaning "ink picture," was brought to Japan around the seventh century A.D. by Japanese scholars returning from a visit to China. They brought back to Japan many cultural ideas, among which were calligraphy (beautiful writing) and a style of painting influenced by it. The Japanese adapted this Chinese painting method to their own culture, added their flair, and called it sumi-e.

Sumi-e was woven from four strands, called the Four Gentlemen: Bamboo, Wild Orchid, Chrysanthemum, and Plum Branch. Each one introduces a new stroke or idea that reinforces the stroke before. Ancient Chinese artists were reported to have said that the Four Gentlemen represent all the forms and shapes in the universe. Some also said that they were called the Four Gentlemen because only men of wealth had the leisure time to practice and enjoy calligraphy and painting! Oriental art history, however, shows us that there were famous women and even children painters.

When sumi-e was introduced into Japan, the Zen Buddhist priests used it in their teaching programs as a Zen exercise. They valued the absence of color (monochromaticism), which emphasized line, shading, and emotion. They thought it was more challenging and exciting than color, and required more discipline.

There are many folk stories about sumi-e. One in particular was about Sesshu, a Japanese master painter from the fourteenth century. As a boy, he displeased his abbot by drawing instead of studying his religious lessons. As punishment he was tied to a tree so that he would be forced to meditate. Instead, he drew such lifelike mice with his toe in the sand that they suddenly came to life and freed him by chewing through the ropes that held him.

There are many other sumi-e legends, some translated and charmingly illustrated by Lafcadio Hearn under the title of "The Boy Who Drew Cats."

Another legend tells of an emperor who decided to pit one sumi-e artist against another, and told them to paint maple leaves floating down a stream. One artist painstakingly painted the floating leaves in great detail. The other, annoyed at the idea of the competition, took a rooster, dipped its feet in red paint, and pressed them on a long sheet of rice paper that represented the stream.

Many Western artists have studied sumi-e or been influenced by it. The work of famous artists such as Toulouse-Lautrec, Gauguin, van Gogh, and Mary Cassatt reflects the Japanese influence of sumi-e. The story goes that some Japanese dishes, wrapped in discarded wood-block prints, were delivered to a cafe in Paris that was frequented by the young impressionists. They admired the sureness of the thick-thin sumi-e strokes (necessary for a wood-block print), as well as the color and composition used in the prints. As a result they formed a group to discuss Japanese art.

Today the beauty and freedom of the sumi-e line is admired by numerous painters, who refer to this style as "action painting." Many Japanese families spend their leisure hours enjoying their hobby of shodo (calligraphy) and sumi-e. ❧

The Sumi-e Spirit

Sumi-e is full of spirit and individuality. One stroke leads effortlessly to another when the artist has complete control of his mind and brush. It is an immediate painting. Try to make each stroke the most beautiful you can, the final stroke each time.

To keep the spirit of sumi-e fresh, it is better *not* to make preliminary sketches. The picture is already in your mind. Enjoy a beautiful scene and paint the memory and the emotion of it in the sumi-e language. A composition can emerge in black, shades of gray, and white (negative space) that can suggest a whole spectrum of color. This is sumi-e in its highest form. It is realistic or abstract, but it is always impressionistic.

Sumi-e helps the painter remember the beauty of familiar sights: the way a lizard looks and moves on a bamboo leaf, a bird on the wing capturing a butterfly, a dragonfly hovering over twisted grasses, a bee darting from flower to flower. Sumi-e helps you remember beautiful things you have seen and transform them into pictures that other people can enjoy too.

To the ancient Chinese, sumi-e embodied the Tao, the constant principle of the universe, the road of life. The same spirit has dwelt in the minds of sumi-e painters for eons. Know that Hokusai, Sesshu, Buncho, and many other great sumi-e painters are at your side, trying to help you do the thing they loved. ❧

The Sumi-e Language

The sumi-e language helps you memorize beauty in brushstrokes. You combine emotion with your memorized strokes, and they remain in your mind forever, a kind of visual vocabulary that lets you see the world in a completely new way.

An old Chinese proverb says: "In order to be a free painter you must learn to copy." Compare this thought to writing a story. You cannot write a story unless you can write words. In order to write words you must memorize the alphabet and learn grammar. In sumi-e the alphabet is the brushstrokes and the grammar is the composition. You must practice the basic strokes, so they will flow freely like writing, without effort, leaving your mind free for the composition and emotion.

Sumi-e is a personal art, as personal as one's signature. To make it your own, you will need patience, persistence, and eye-hand coordination and imagination. Imagine a sumi-e painting flowing as freely as a piano concerto. Surely the notes had to be practiced in order to make beautiful music.

Sumi-e is a natural companion to Japanese "haiku" poetry.

"Cadence"
by Shôha

Spring rain on my roof begins to drum:
Drips from the willow, petals from the plum.

What could be more inspiring to paint than an illustration of this haiku? The poem in flowing calligraphy and a sumi-e illustration would make a wonderful wall hanging.

Sumi-e was used to make early moving pictures. The illustrations and story in calligraphy were painted on a hand scroll that rolled sideways and was viewed through a box. I saw these moving pictures as late as 1955 being used as entertainment for children in outlying villages.

Japanese history was recorded on scrolls of paper or fabric with calligraphy and sumi-e paintings. These scrolls help historians as well as artists to see life in centuries past. Early hydrographic and topographic maps were done in brushstrokes; experienced sailors have told me that they are superior to the charts used today. Artists who protested social conditions or created political cartoons painted their works on sumi-e scrolls. Sumi-e is a language in itself. 🍃

Sumi-e Materials

***T**he three major elements are* the brush, the ink and the paper.

The classical sumi-e brush, called fude (foo-day) is always essential because of its unique shape. The bristles may be the hairs of badgers, deer, sables, weasels, rabbits, or other animals. Beware of mixed hairs.

An old story tells of a Chinese master who saved each of his cat's lost whiskers to put together into a brush. I have even heard of the hairs from children's first haircuts being very desirable for brush making. Another story is told of a Japanese shogun who was an active environmentalist, and forbade the use of animal hair for brushes. Instead, the ends of bamboo brush handles were shredded and tapered into brushes. I once used such a brush with fine results.

The fude has a very special shape. The brush tip has a full body that holds a lot of moisture and tapers to a very fine point. A medium-size brush (around size 4) is the best brush to start with. As you add more brushes to your supply, purchase every other size, such as sizes 0, 2, 6, and so on.

The hake (hah-kay) is a flat brush, also tapered, and comes in a complete range of sizes. This brush is very useful for bamboo stalk strokes, smooth washes, and other special effects. In the olden days before the advent of the airbrush, architects used the hake for smooth washes in large areas.

I have also heard that Japanese brides use these brushes to pat rice powder on their faces in the traditional fashion for wedding makeup.

When you finish using the fude or hake, gently rinse it and store it with the bristles up. If there is a loop at the top of the brush, hang the brush by that. Rolling brushes in a bamboo place mat is also a good way to store them.

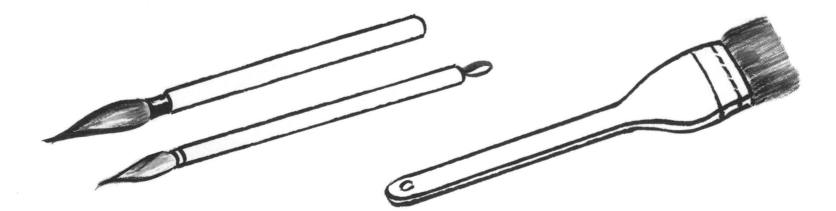

The second important element is the paint, which can be watercolor or sumi ink. Although acrylic paint is water-soluble, it is very bad for the sumi-e brush.

Long before the Han Dynasty (207 B.C. to 220 A.D.) sumi ink sticks were being made from a mixture of soot, water, and glue. When rubbed in water on a piece of slate called the suzuri (soo-zoo-ree), the sumi stick produced rich black ink. Sumi ink sticks come in many grades, ranging from a brownish black to a deep blue black. They may have beautiful designs and calligraphy molded into them, and a delightful fragrance. Suzuri can be decorative too.

Nowadays we have very good watercolors, which are the perfect companion to the sumi brush. Although I enjoy the colors, I usually use the sumi ink stick for really rich black.

Finally the third element, the paper. Beginners should practice on newsprint, learning to control their strokes on this cheap but serviceable paper. When control has been achieved, rice papers are the next step. Try the many kinds of rice papers, such as gasenshi, wagasen, and then on to hosho. Different rice papers produce different effects. Other papers, such as absorbent watercolor paper, Canson Mi-teintes with its different-colored backgrounds, and even construction paper can occasionally be used. Finally, when every stroke is a thing of beauty, you can paint on silk.

Whatever painting surface you choose, weight or tape two edges in place over a larger sheet of paper, or on a surface that can be wiped, such as a Formica board. This will enable you to stroke so freely that you can go right off the edge of the paper. If you are using rice paper, it is also important to have an absorbent cloth directly underneath it.

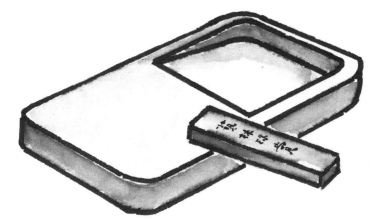

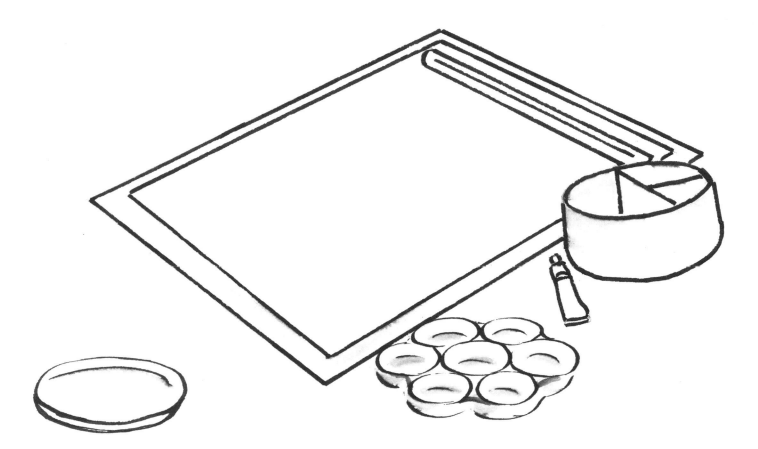

The last of the necessary accessories are the water bowl and the palette. Many Oriental shops carry attractive porcelain accessories that are delightful. I really prefer a larger water bowl and an undivided palette. A small divided palette inhibits my work. It is also crucial to have a good absorbent cloth to take the excess water from your brush.

My sensei (Japanese master teacher) stressed this tip: For smoother painting, set your materials on the right if you are right-handed (on the left if you are left-handed).

So now you are ready to paint. Remember to keep your painting area uncluttered and conveniently arranged. Be comfortable, with good light, and keep peace of mind by filling your mind with the essence of your painting, even when you are only practicing! ❧

Painting the Sumi-e Way

When a brush is new, it is stiff with fish glue, so wash it out until it is soft before you try to paint. It is very important that you hold your sumi-e brush vertically with your thumb and first two fingers. (The brush is slanted only for special strokes.) Although the brush is usually held in the middle, it is natural to hold it close to the bottom for small strokes, and at the top for large strokes.

Your paper should be flat on the drawing table and you should sit erect over your art. The Japanese usually sit on their heels over a low table for the proper height. With the right posture and position, you should be able to move very freely with your whole arm (as if it were in a solid cast), with the stroke action coming from your shoulder. With this motion you will be using your whole body to help execute your strongest, loveliest strokes every time.

Sometimes the sumi-e brush is called the dancing brush, and sumi-e is called action painting. The strokes should flow on the paper as freely as if you were writing a letter. *Do not be limited by the edges of the paper*. Always flow the action off the paper, not allowing the boundaries to cripple you or inhibit your stroke. Sometimes the stroke action is compared to the physical follow-through of the golf stroke or the tennis swing.

All these thoughts should help you remember to try to *paint with a full, free arm movement*.

If there is a picture to be viewed while you work, place it directly in front of you on a small easel so that you can glance up at it without moving your head. It is important to be comfortable so that your energy level is maintained and you can complete a painting in one sitting. ❧

Yolanda's Ten Rules

***O**ver the years* I have taught sumi-e to many beginners, both adults and children. Experience has taught me that the following ten rules make sumi-e much easier to learn.

1. Hold the brush vertically, unless otherwise instructed for a special stroke.

2. Pull your brush in the direction of the arrows, if arrows are shown.

3. For a shaded brush, load your brush with a light wash and shade it with a stronger color. Depending on the stroke, the shading can be on the tip, on the bottom half, on one or both edges, or on the top half. You can apply shading to your brush with a second brush.

4. Always practice in a way that will lead naturally to a finished painting: Practice in composition (not isolated details), and with a shaded brush for strokes that require it.

5. Learn versatility by brushing your strokes from right to left *and* left to right. Some strokes should be practiced in all directions.

6. For most sumi-e compositions, start in the foreground and work back.

7. Paint soft things like fur and downy feathers with a light wash. For harder objects, such as birds' beaks and legs, use darker, thicker paint.

8. Practice graduated strokes—that is, the same stroke getting smaller and smaller—every day to develop dexterity, no matter what size your brush is.

9. Try to practice at least fifteen minutes a day.

10. Once you have learned the four basic strokes (the Four Gentlemen), try to make all your paintings your own creations.

If you keep these rules in mind as you go along, you will already have avoided many of the mistakes that beginning sumi-e painters typically make. And if you master sumi-e well enough to want to teach it to anyone else, you will find the ten rules very useful in either a one-on-one or a classroom situation. ❧

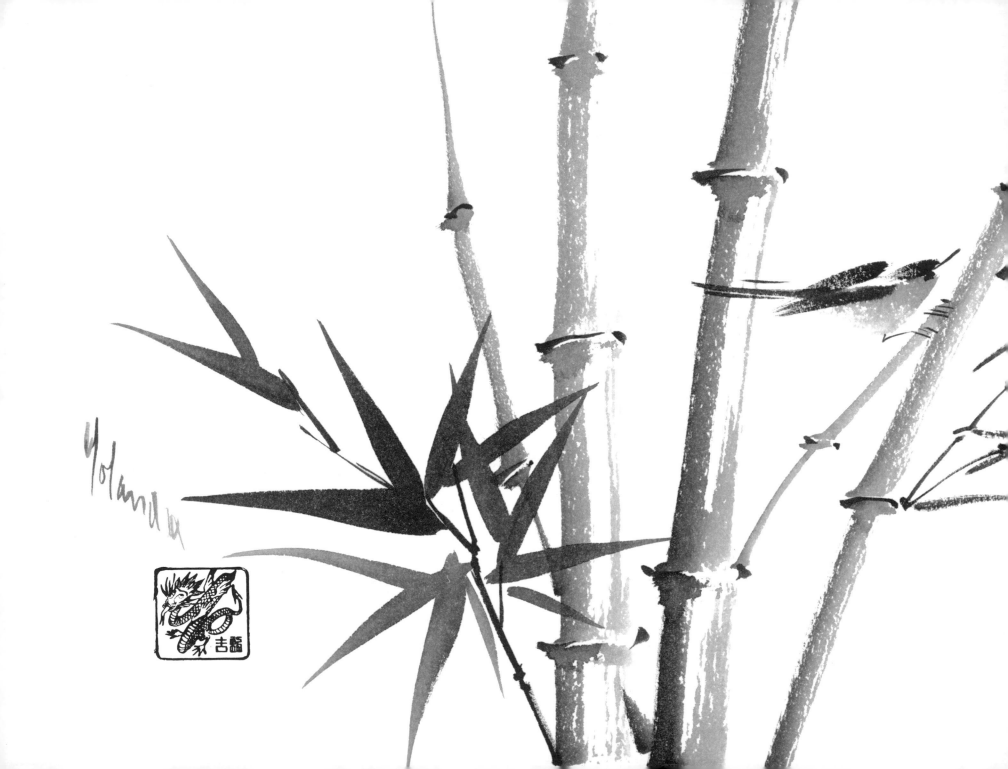

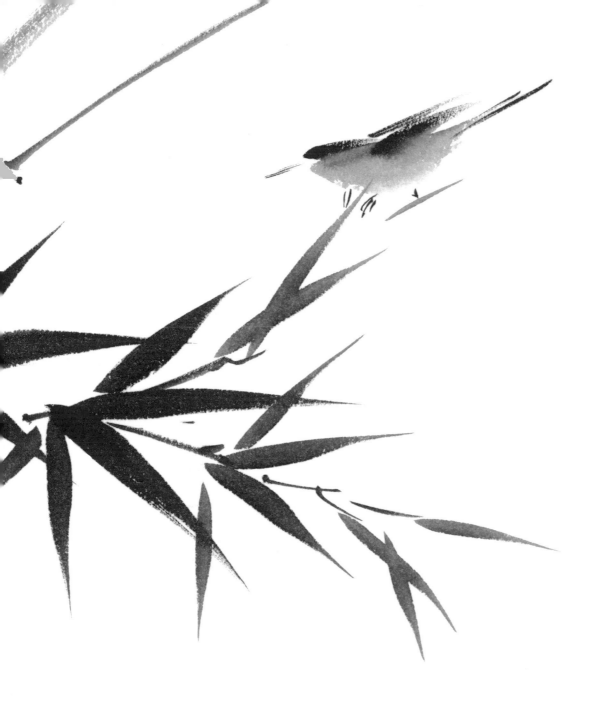

BAMBOO

The Bamboo Brushstrokes

There are three kinds of bamboo brushstrokes: one for the leaf, one for the stalk, and one for the node between segments of the stalk. With these three strokes you can paint elegant bamboo trees. Related strokes will let you paint birds, insects, mushrooms, and even people!

The Bamboo Leaf

Load your brush with gray and tip it with black. Then hold it vertically.

Drag just the tip of the brush to make thin, black lines.

To make a bamboo leaf, first drag the tip, then press down, and finally lift the brush up and away, like a plane taking off.

Practice making smaller and smaller bamboo leaves to learn control of your brush.

Then practice making the leaves grow in all directions, without turning your paper.

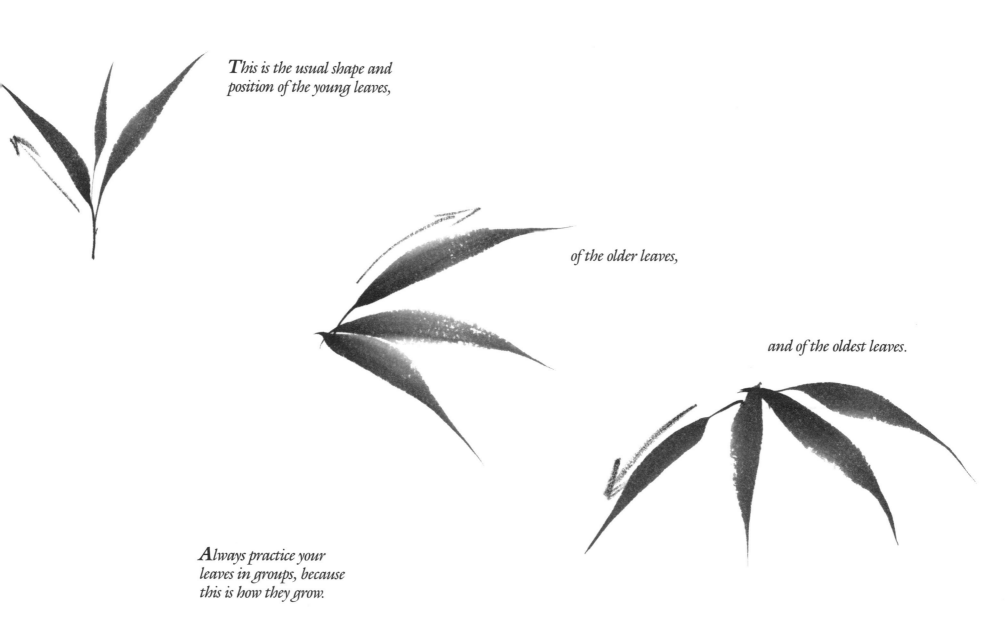

This is the usual shape and position of the young leaves,

of the older leaves,

and of the oldest leaves.

Always practice your leaves in groups, because this is how they grow.

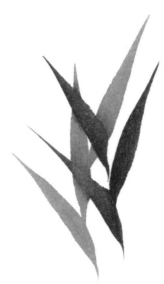

Now add more groups. The paint is less likely to run if you paint the black leaves first, then add the gray ones.

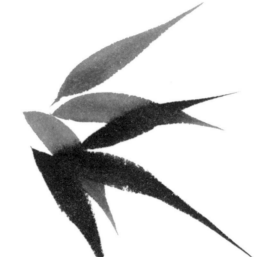

Overlapping leaves are more beautiful than single groups.

Use black leaves for the foreground, and smaller grayer leaves for the background groups.

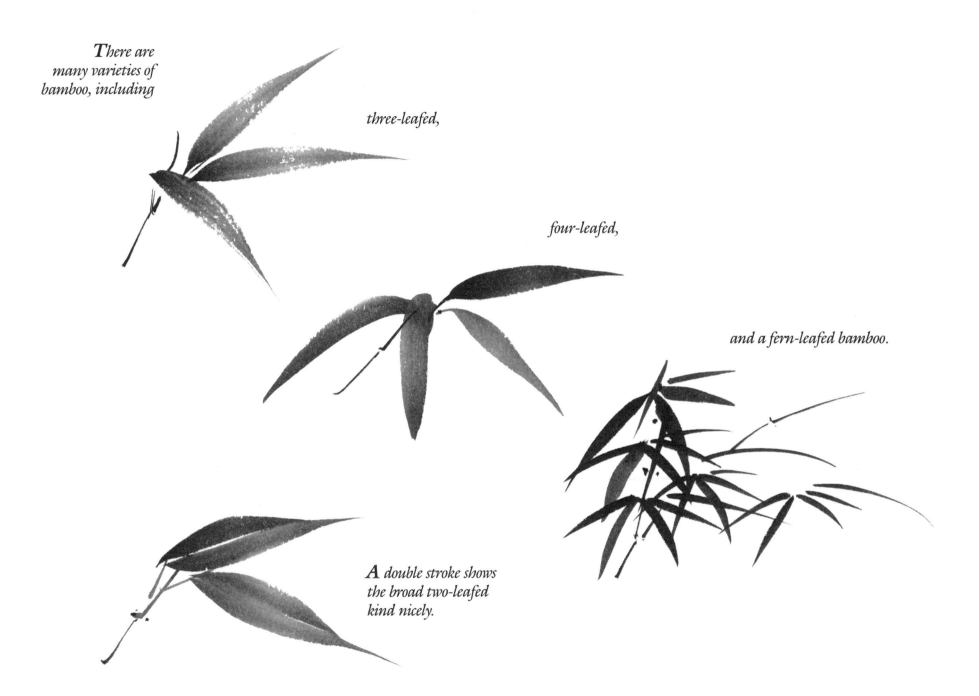

*T*here are
many varieties of
bamboo, including

three-leafed,

four-leafed,

and a fern-leafed bamboo.

A double stroke shows
the broad two-leafed
kind nicely.

Many moods can be set with bamboo.

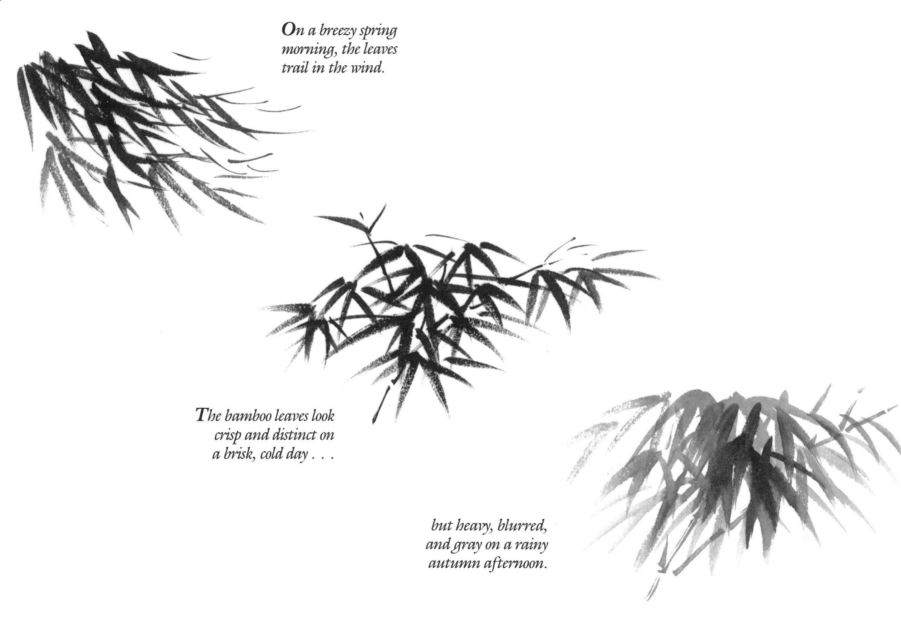

On *a breezy spring
morning, the leaves
trail in the wind.*

The *bamboo leaves look
crisp and distinct on
a brisk, cold day . . .*

*but heavy, blurred,
and gray on a rainy
autumn afternoon.*

The Bamboo Stalk

Start at the bottom and paint upward. Press, lift and pull, press again, and leave a space.

Practice curved bamboo stalks, not just straight ones.

For this stroke, push the brush sideways. Loading the brush with gray and the tip with black will create shading to make your bamboo stalks look round.

As you practice smaller strokes, use less and less of the brush—and finally just the tip.

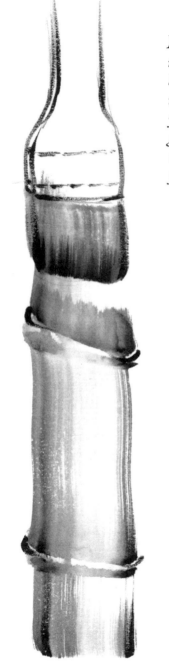

For variety, you may use a hake—a flat brush that comes in many widths. Load your hake with a gray wash, and tip both edges in black for shading.

You can use a narrow hake to paint thin stalks and twigs, for an interesting composition.

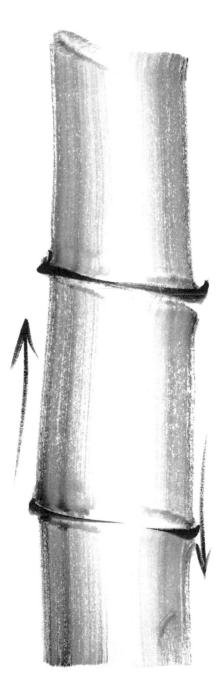

For wide bamboo, you can double your shaded stroke. If you use a hake for this, tip only one edge in black, and keep it toward the outer edge of the bamboo (not the middle).

Practice bamboo stalks and twigs that cross at interesting angles. The white spaces between them are as important as the stalks themselves.

The Bamboo Node

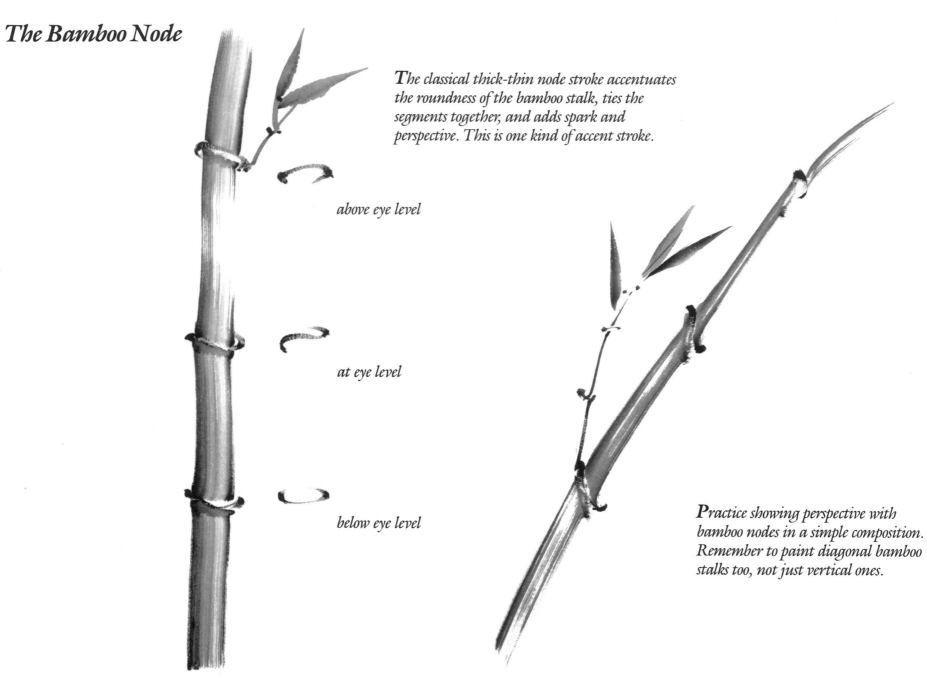

The classical thick-thin node stroke accentuates the roundness of the bamboo stalk, ties the segments together, and adds spark and perspective. This is one kind of accent stroke.

above eye level

at eye level

below eye level

Practice showing perspective with bamboo nodes in a simple composition. Remember to paint diagonal bamboo stalks too, not just vertical ones.

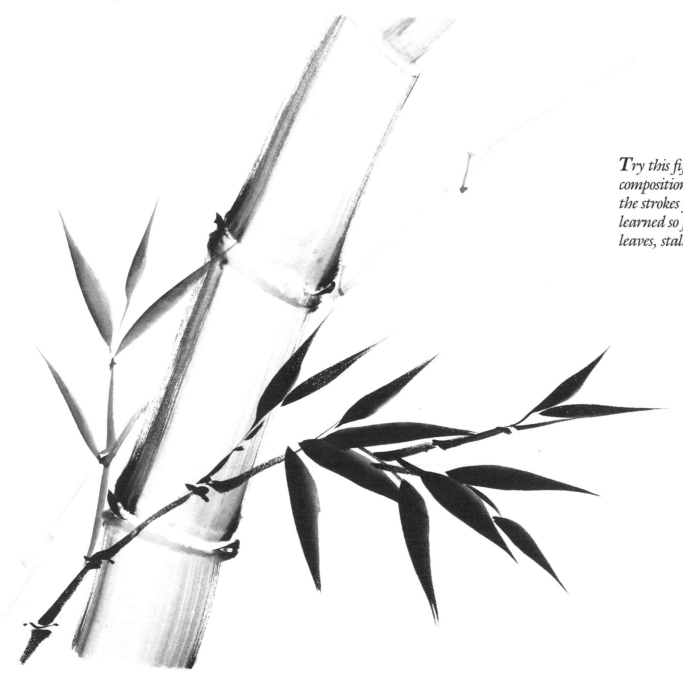

*T*ry this fifteen-minute composition. It combines the strokes you have learned so far for bamboo leaves, stalks, and nodes.

Related Strokes

Now that you have learned how to paint bamboo trees, you are ready to discover some very similar strokes. Although bamboo is a plant, the strokes based on it will let you paint many kinds of animals.

Bird

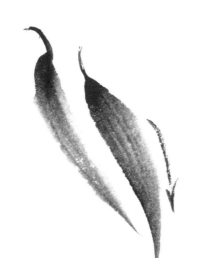

To make the body of a bird, paint two bamboo leaves curved toward each other. (Leave off the stems.)

Add a small curved bamboo leaf, again without a stem, for the head.

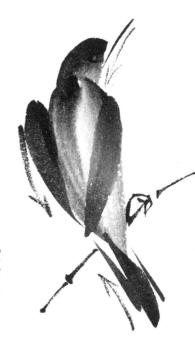

Beak, wings, feet, and three strokes for the tail feathers complete the back view of the bird.

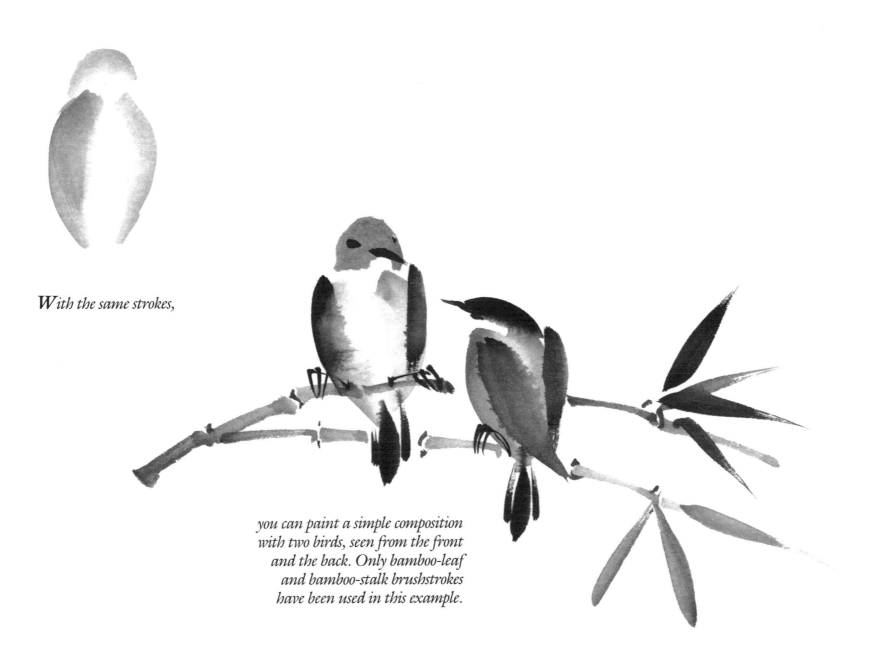

With the same strokes,

you can paint a simple composition with two birds, seen from the front and the back. Only bamboo-leaf and bamboo-stalk brushstrokes have been used in this example.

For a different view, start to paint a stemless bamboo leaf from right to left. Now push down at an angle toward you so that the bristles of your brush are lying almost flat, then pull up and away toward the left for a wedge-shaped stroke.

The same stroke used for the bird's body, turned upside down, is a wing stroke.

This "bird stroke" is useful for all wing positions, whether the bird is flying or resting.

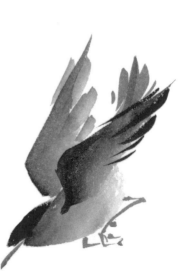

Paint the accent strokes for the beak and feathers. Legs and feet are tiny bamboo twigs.

Practice reversing the strokes for this bird.

This one has the same strokes pulled upward. Practice until you can paint all these birds just as easily.

The strokes you have just
learned can be used for all
these bird positions.

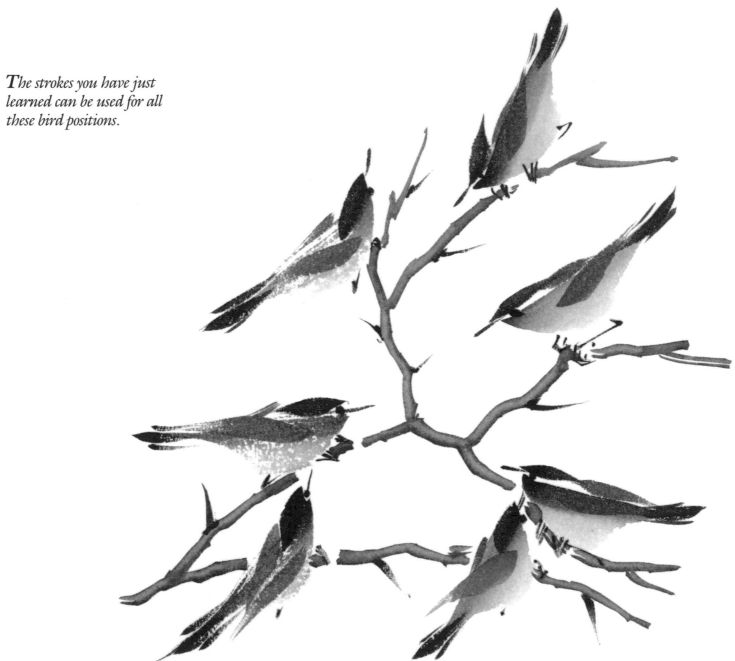

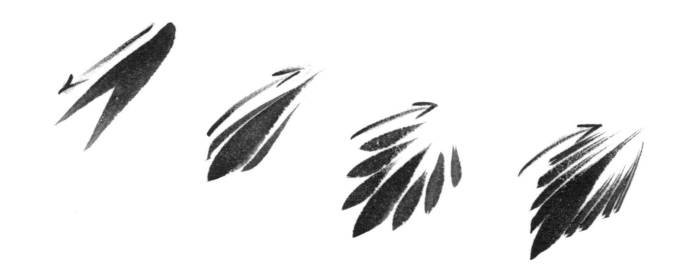

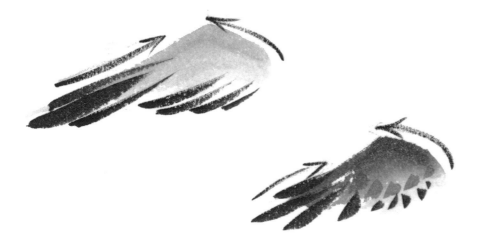

Practice painting tail and feather strokes of many lengths and widths, so that you can paint tails like these, for all kinds of birds!

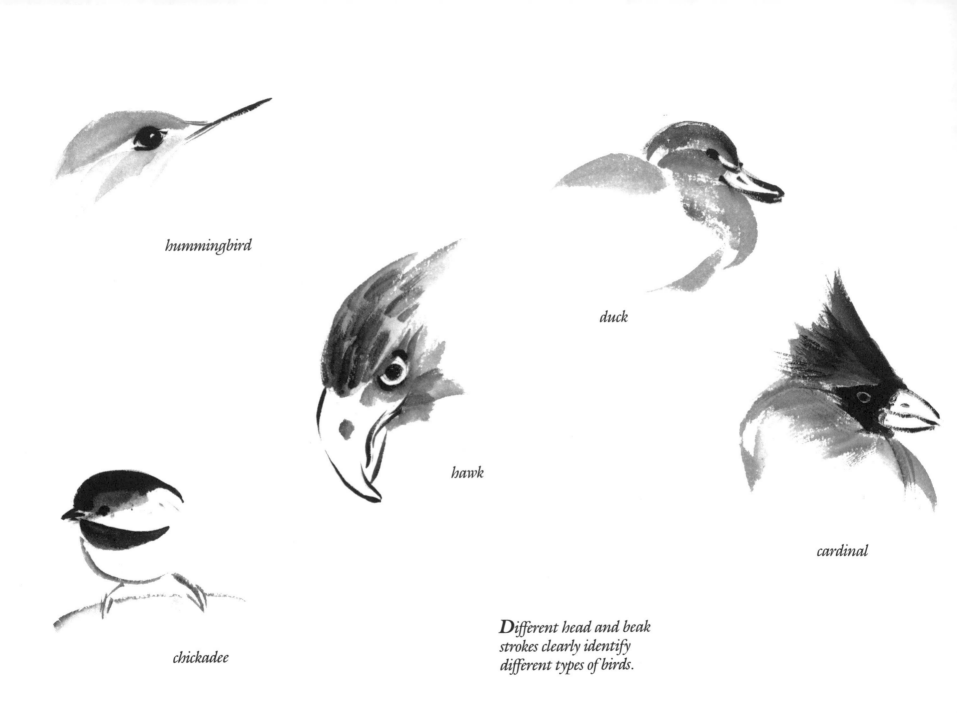

hummingbird

duck

hawk

cardinal

chickadee

Different head and beak
strokes clearly identify
different types of birds.

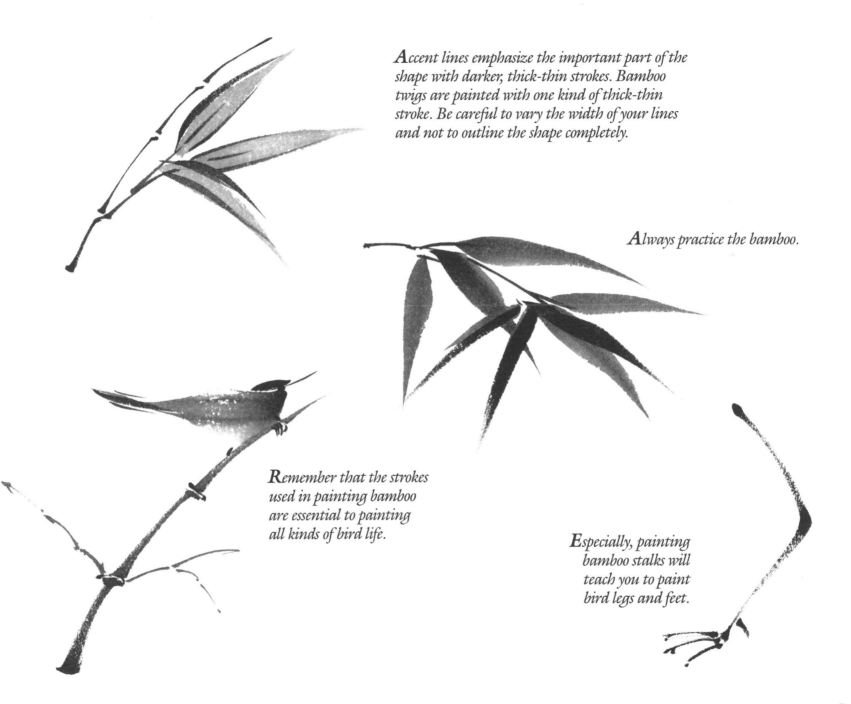

Accent lines emphasize the important part of the shape with darker, thick-thin strokes. Bamboo twigs are painted with one kind of thick-thin stroke. Be careful to vary the width of your lines and not to outline the shape completely.

Always practice the bamboo.

Remember that the strokes used in painting bamboo are essential to painting all kinds of bird life.

Especially, painting bamboo stalks will teach you to paint bird legs and feet.

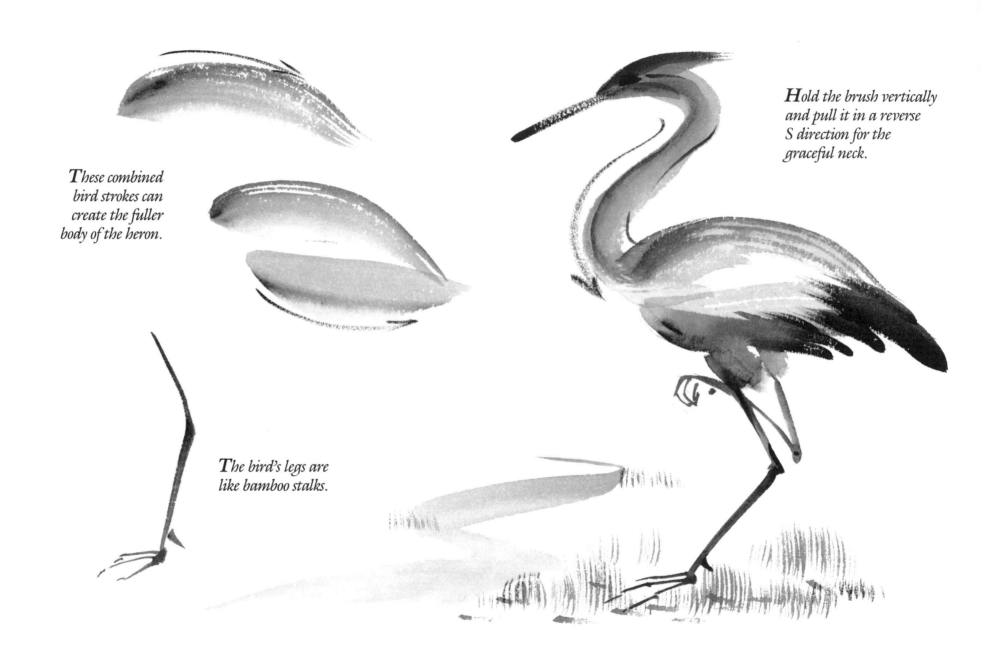

These combined bird strokes can create the fuller body of the heron.

Hold the brush vertically and pull it in a reverse S direction for the graceful neck.

The bird's legs are like bamboo stalks.

A penguin is nothing but a bird.

Hold the brush vertically to do a bamboo-leaf stroke for the head.

Hold the brush at a 45 degree angle for the wing, and brush toward the body.

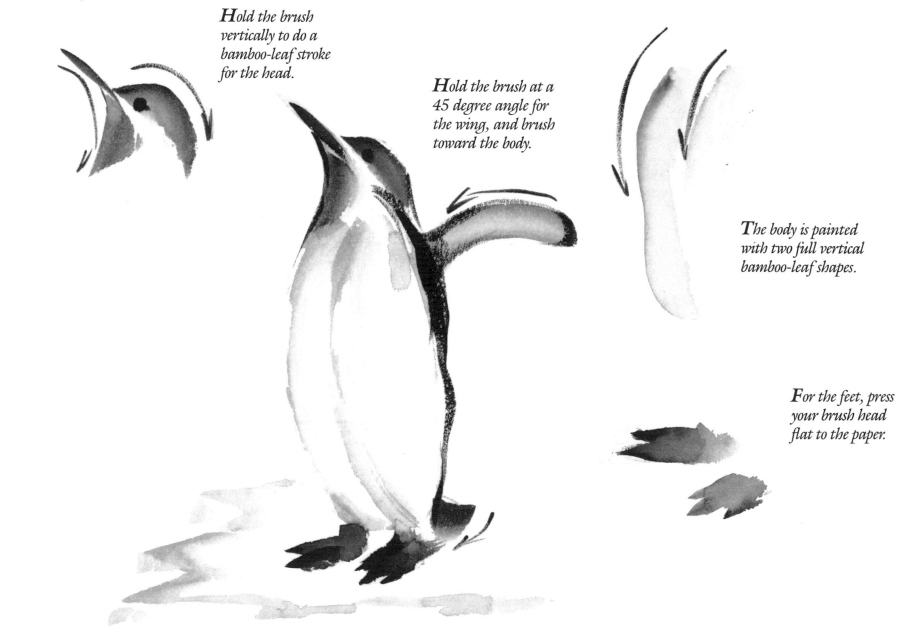

The body is painted with two full vertical bamboo-leaf shapes.

For the feet, press your brush head flat to the paper.

Butterfly

To paint butterflies,
first practice the
bamboo leaf, then
the bird stroke.

Now brush this stroke
in all directions.

Here is a simple butterfly
looking to the left,

to the right,

and straight ahead.

The butterfly's body is painted
in black after the wings,
using the tip of the brush.

*H*ere's another way to paint butterflies.
Be sure to hold your brush at a
45 degree angle for this stroke.

*F*irst paint
the wings,
then the
body parts.

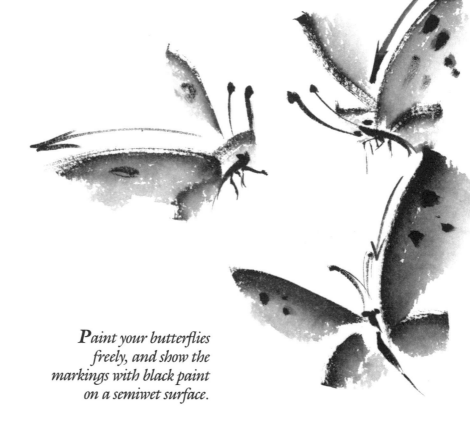

*P*aint your butterflies
freely, and show the
markings with black paint
on a semiwet surface.

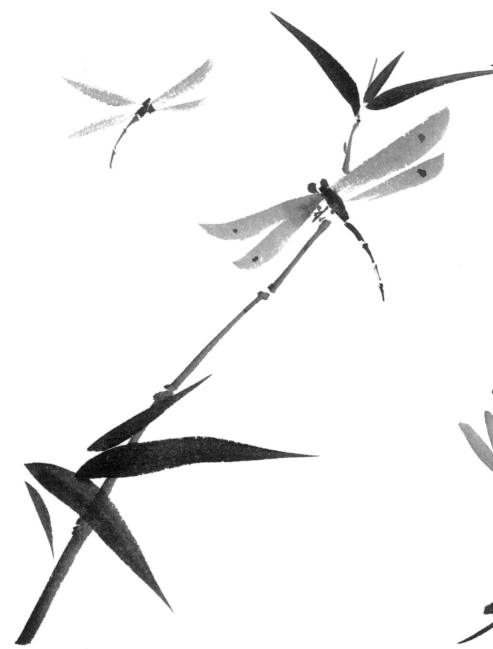

Using strokes you've already learned, you can paint many kinds of insects. Observe them closely and try to paint their shapes with simple single strokes.

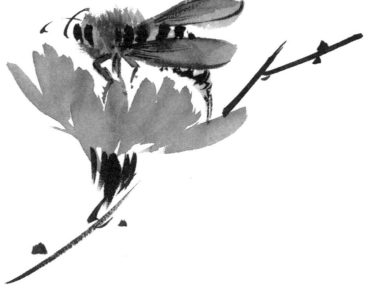

Lizard

To paint a lizard, start with
a bamboo leaf without a stem.
Now wiggle the stroke.

For his legs, hold the brush at a 45 degree
angle and follow the arrows. Add the
toes with the tip of your brush.

Put all the lizard's body
parts together. The mouth and
eyes are the finishing touches.

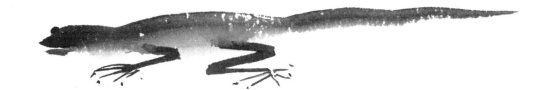

Spider

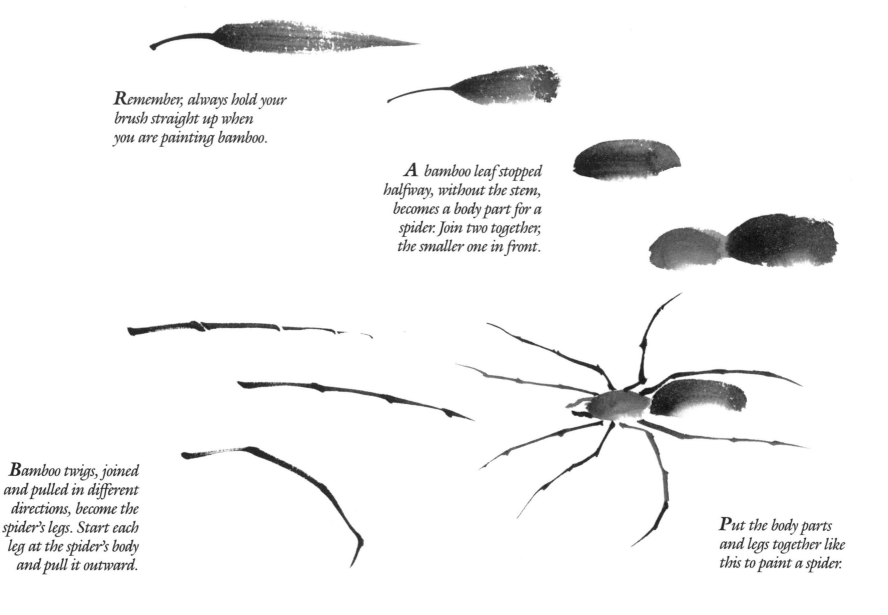

Remember, always hold your brush straight up when you are painting bamboo.

A *bamboo leaf stopped halfway, without the stem, becomes a body part for a spider. Join two together, the smaller one in front.*

Bamboo *twigs, joined and pulled in different directions, become the spider's legs. Start each leg at the spider's body and pull it outward.*

Put *the body parts and legs together like this to paint a spider.*

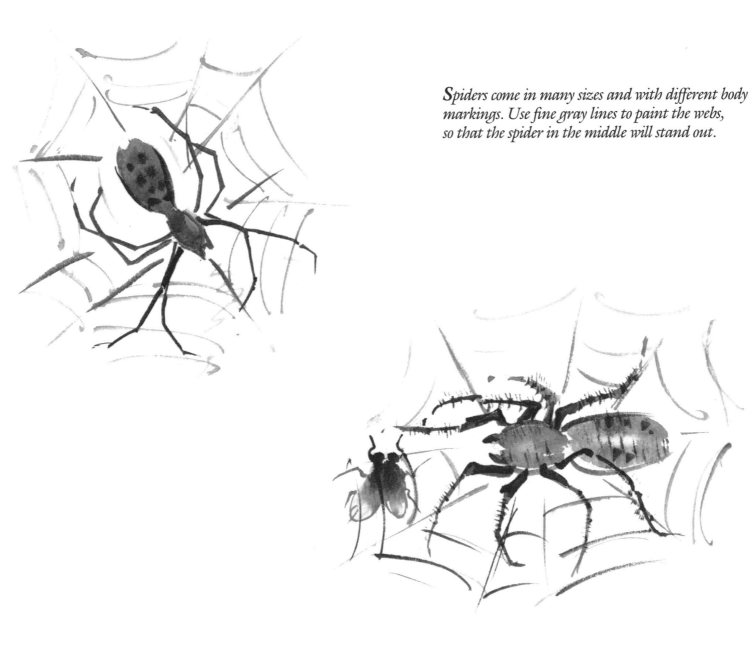

Spiders come in many sizes and with different body markings. Use fine gray lines to paint the webs, so that the spider in the middle will stand out.

Walking Stick

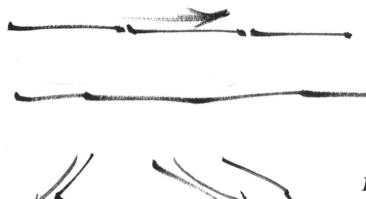

Painting bamboo twigs like these is the first step toward painting a twig, or the legs of a walking stick. Be sure to hold your brush vertically.

Now do not lift your brush between segments.

For legs, practice segments that bend in all directions. End each stroke with a tiny curve.

Use the same modified bamboo stroke to paint tree twigs. These have curves and bends, so do not paint them as straight as bamboo twigs.

Now add a long, slightly curved stroke for the insect's body, and two very thin lines with your brush tip for antennae. By putting all these strokes together, you can paint a walking stick moving down a twig.

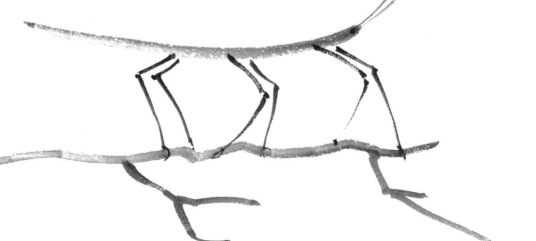

Praying Mantis

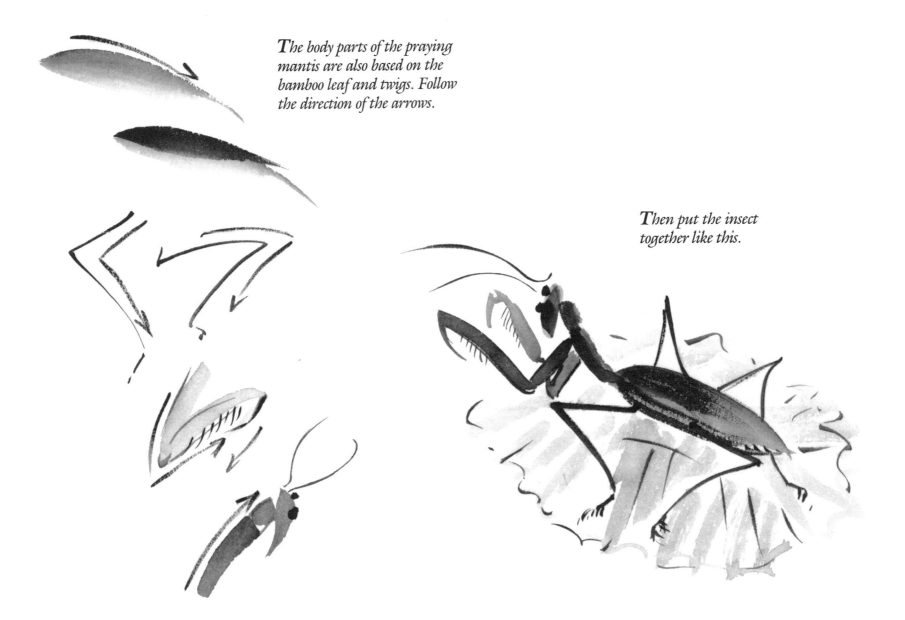

The body parts of the praying mantis are also based on the bamboo leaf and twigs. Follow the direction of the arrows.

Then put the insect together like this.

Ladybug and Grasshopper

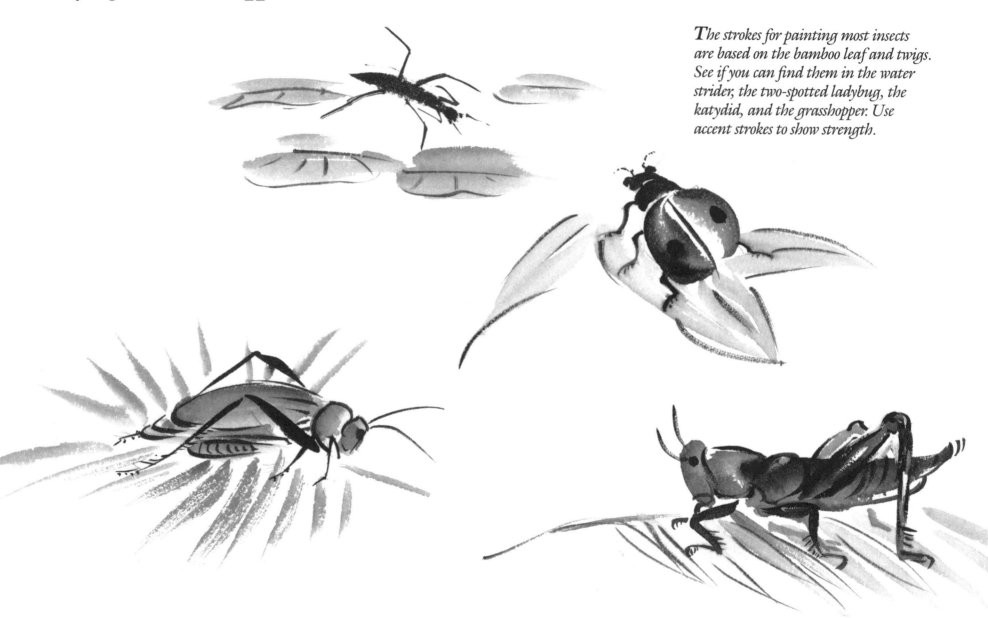

The strokes for painting most insects are based on the bamboo leaf and twigs. See if you can find them in the water strider, the two-spotted ladybug, the katydid, and the grasshopper. Use accent strokes to show strength.

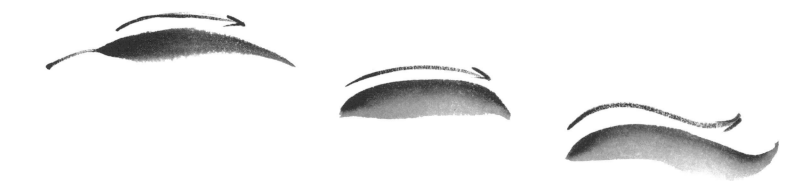

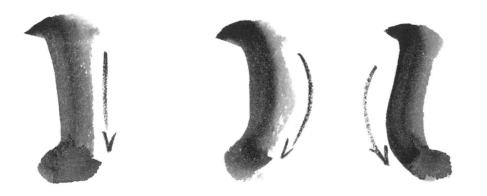

The bamboo stalk, curved to the left or to the right, becomes a stem.

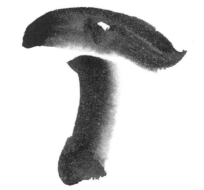

Fit them together and paint a mushroom.

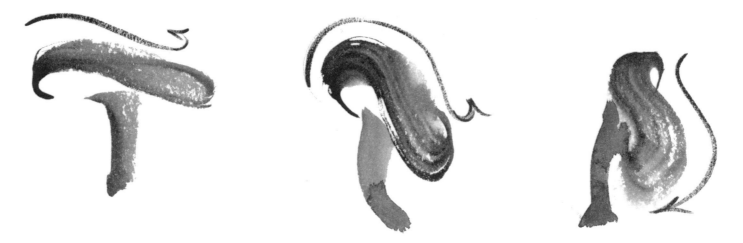

Hold your brush vertically and follow the arrows. Try these strokes in all directions.

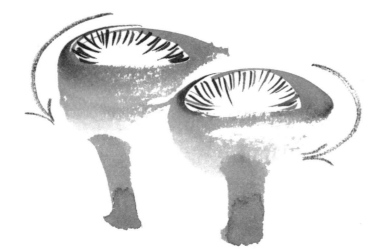

The open areas left by the dry part of the brush are important. They are called flying whites.

After you know the shapes, try the contour line style—suggesting just the edges with a thick-thin stroke. (Do not outline them completely.)

Practice curving the bamboo-leaf stroke smaller and smaller for the mushroom cap. Practice making the bamboo-stalk stroke shorter and shorter for the stem.

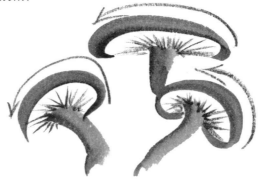

To make mushrooms like these, follow the arrows and paint with a curved motion.

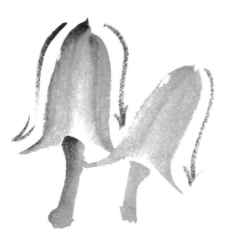

For mushrooms with peaked caps like these, press at the top and pull the stroke down toward you with a rounded motion, always keeping the brush vertical.

For even sharper peaks, lay the tip of the brush down at the top, then press and pull down with a sideways motion.

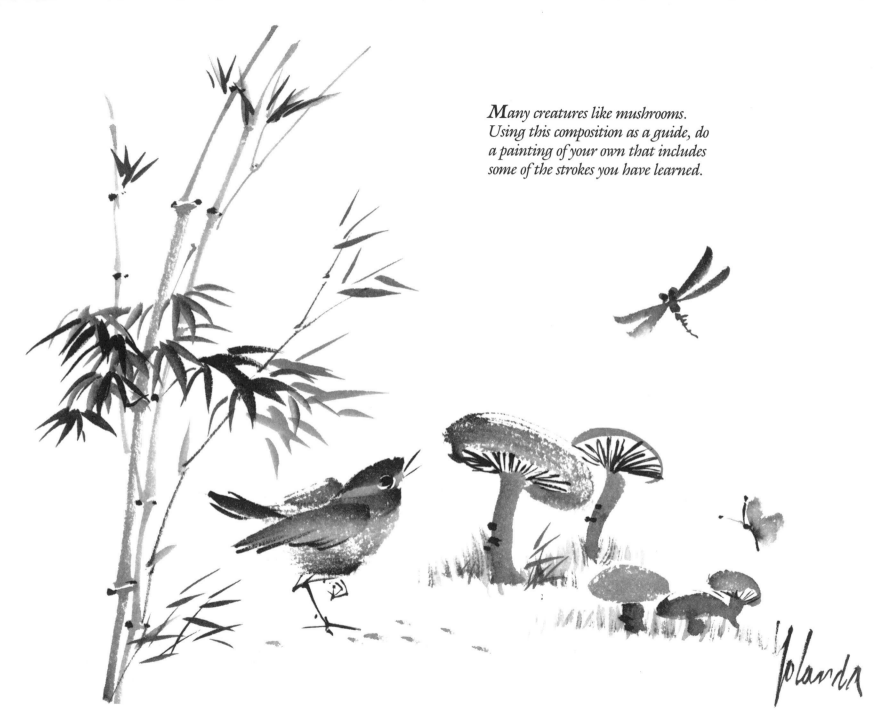

*Many creatures like mushrooms.
Using this composition as a guide, do
a painting of your own that includes
some of the strokes you have learned.*

Yolanda

People

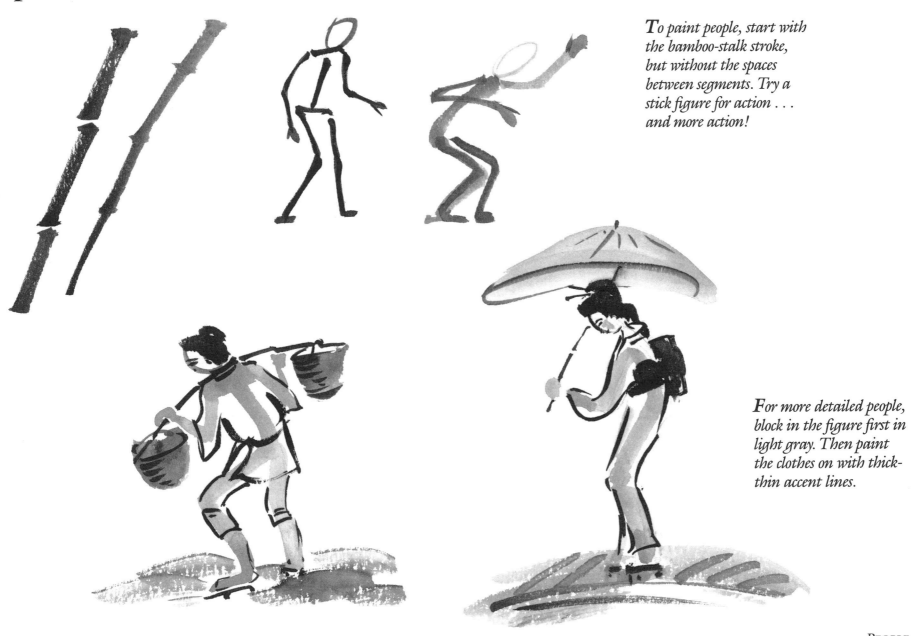

*T*o paint people, start with the bamboo-stalk stroke, but without the spaces between segments. Try a stick figure for action . . . and more action!

*F*or more detailed people, block in the figure first in light gray. Then paint the clothes on with thick-thin accent lines.

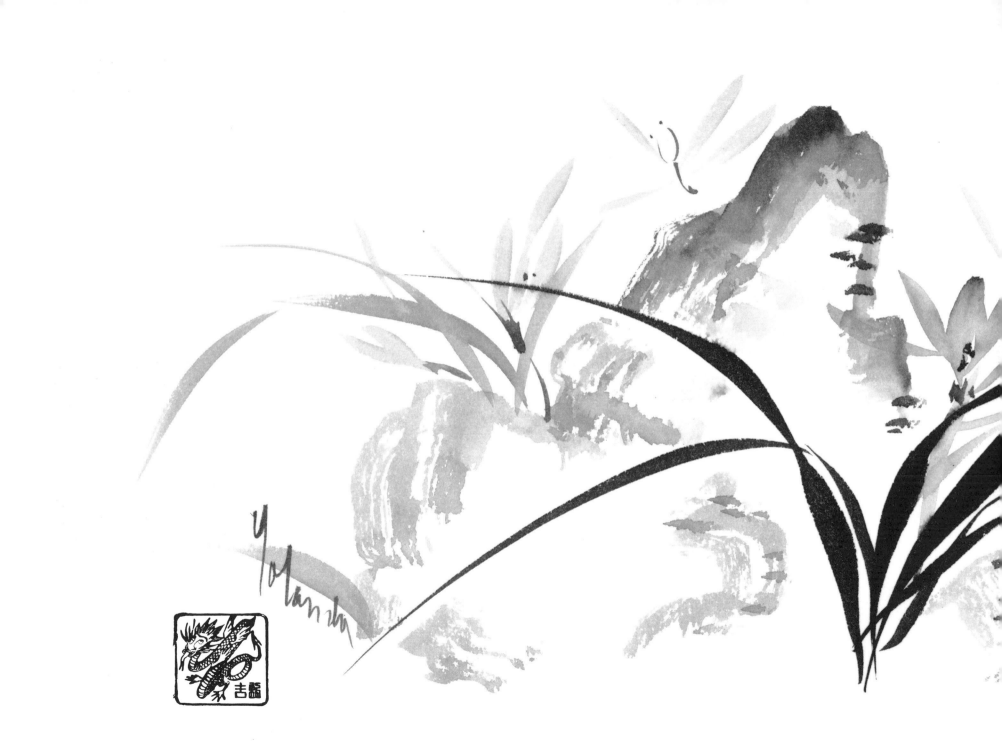

WILD ORCHID

The Wild Orchid Brushstrokes

You will need two brushstrokes to paint the wild orchid: one for the twisting, grasslike leaves, and one for the delicate flower. Both strokes will be useful for other plants and animals later.

The Wild Orchid Leaf

Start with a long, slender bamboo leaf.

Paint several together, tip to tip. Practice doing this without ever lifting your brush from the paper.

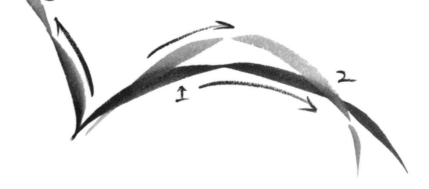

Now arch your strands of joined bamboo leaves, and you are painting wild orchid. For an interesting composition, curve more of your wild orchid leaves in one direction than the other.

The illusion of twisted grasses is created by the tapering brush strokes joined together to form a graceful curve.

Try a composition with three black wild orchid leaves, three medium gray, and three smaller ones in pale gray. The large dark leaves appear to be in the foreground, with the small pale ones in the background. This gives a feeling of depth.

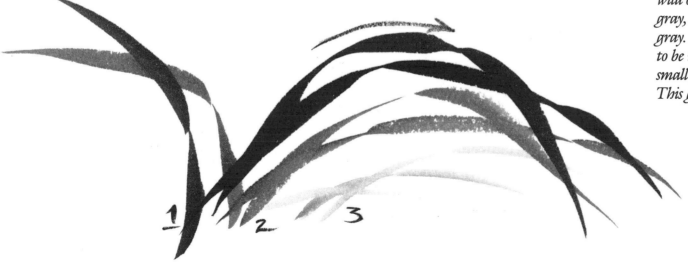

The Wild Orchid Blossom

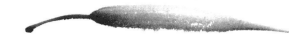

A vertical bamboo leaf without the stem becomes an orchid petal.

All the petals are started at the tips and pulled in toward the center of the flower.

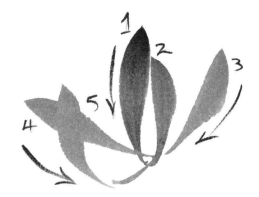

There are many stages of blooming, from opening bud to full-blown flower.

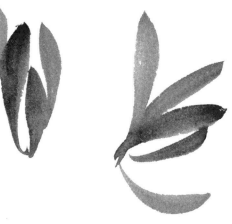

Holding the brush vertically, load the tip with rich black paint. Then make the tip dance over the paper to paint the orchid's stamens.

Two rich black petal strokes form the calyx, the "cup" that holds the flower together.

Finally, a thick-thin brushstroke for the jointed stem completes the wild orchid.

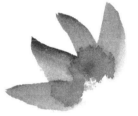

It is important to recognize the wrong strokes so that you won't paint them yourself. These fat strokes vaguely resemble crab claws.

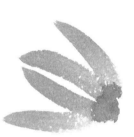

These might be good for bananas or cucumbers.

This looks more like an artichoke than an orchid because the petals' common center has been lost.

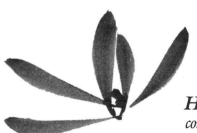

Here are the right strokes. The petals meet at a common center, each one becoming gradually thinner near the bottom. This makes the flower look delicate.

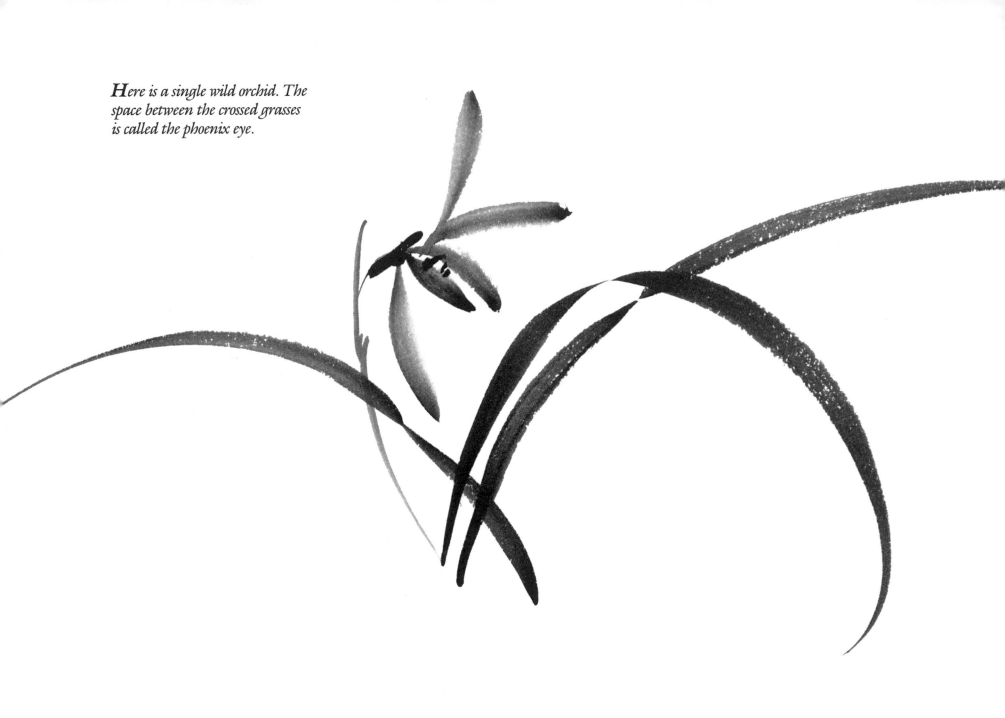

Here is a single wild orchid. The space between the crossed grasses is called the phoenix eye.

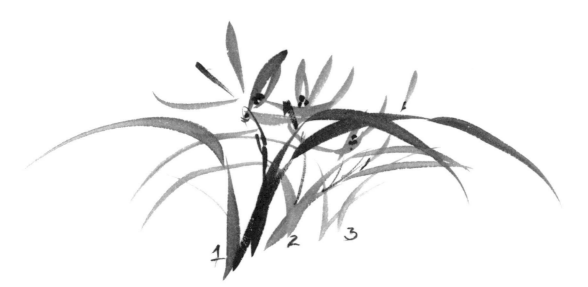

To create a composition of wild orchids, repeat similar groupings three times or more.

Learn to paint orchids upside down without turning your paper, so that they can cascade from a rock,

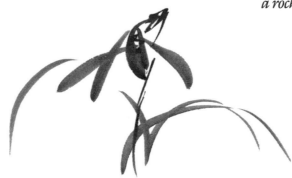

or nod their heads in a meadow heavy with morning dew.

Related Strokes

You can use the bamboo and wild orchid strokes to paint several kinds of fish, underwater weeds, and water lilies.

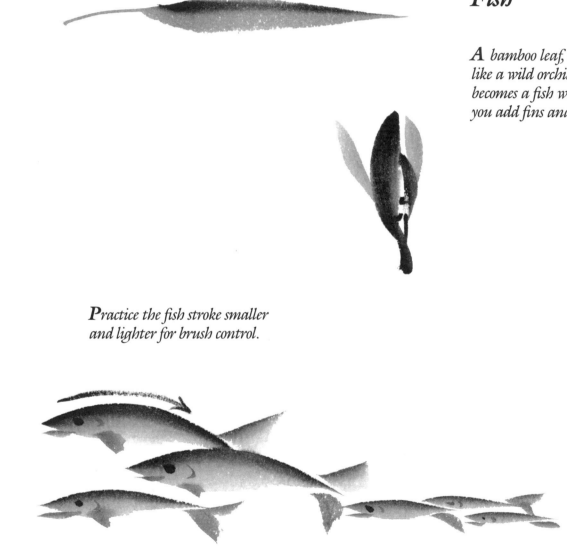

Fish

A bamboo leaf, curved like a wild orchid petal, becomes a fish when you add fins and tail.

Practice the fish stroke smaller and lighter for brush control.

Load your brush with a gray wash and put black ink along the top.

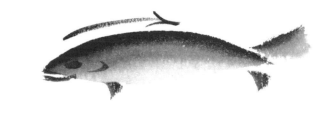

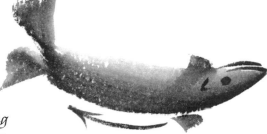

Now you can paint a fish with dark shading at the top—or turn your brush upside down for one with dark shading at the bottom.

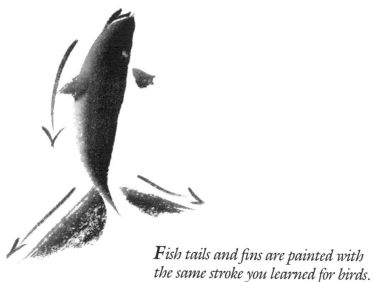

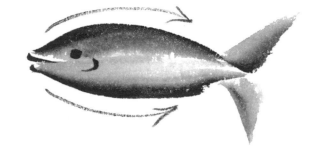

This fish is painted with two main strokes and a few extras for details.

Fish tails and fins are painted with the same stroke you learned for birds.

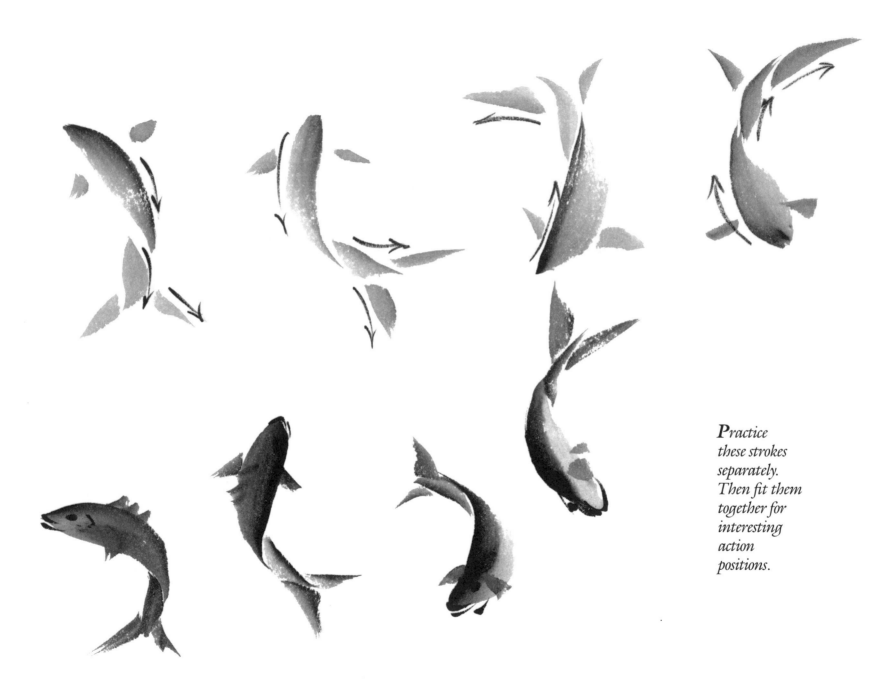

Practice these strokes separately. Then fit them together for interesting action positions.

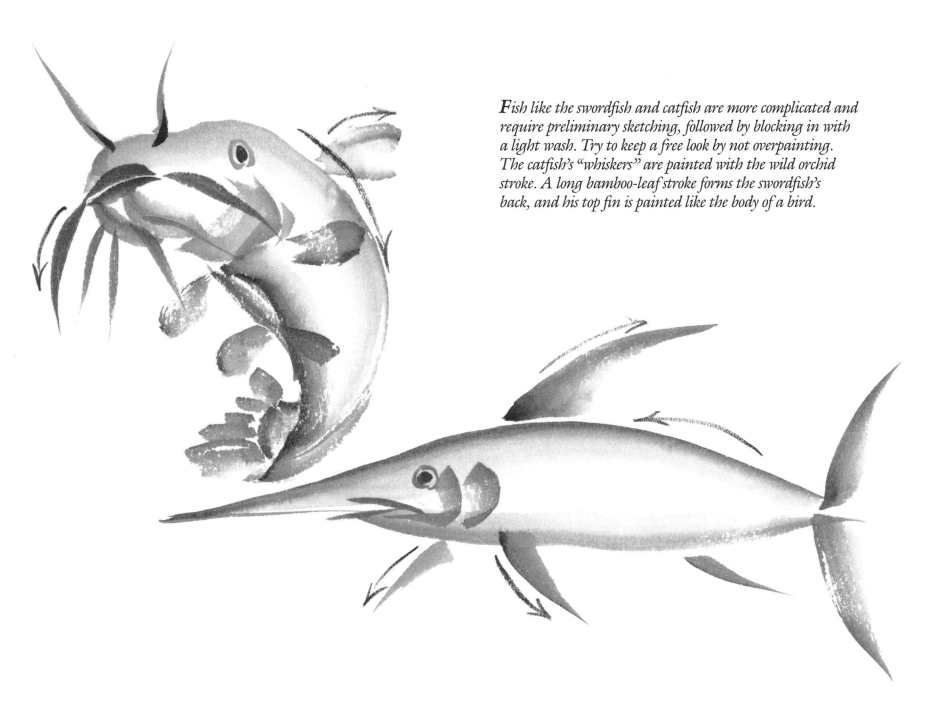

*F*ish like the swordfish and catfish are more complicated and require preliminary sketching, followed by blocking in with a light wash. Try to keep a free look by not overpainting. The catfish's "whiskers" are painted with the wild orchid stroke. A long bamboo-leaf stroke forms the swordfish's back, and his top fin is painted like the body of a bird.

Here are some underwater companions for your fish.

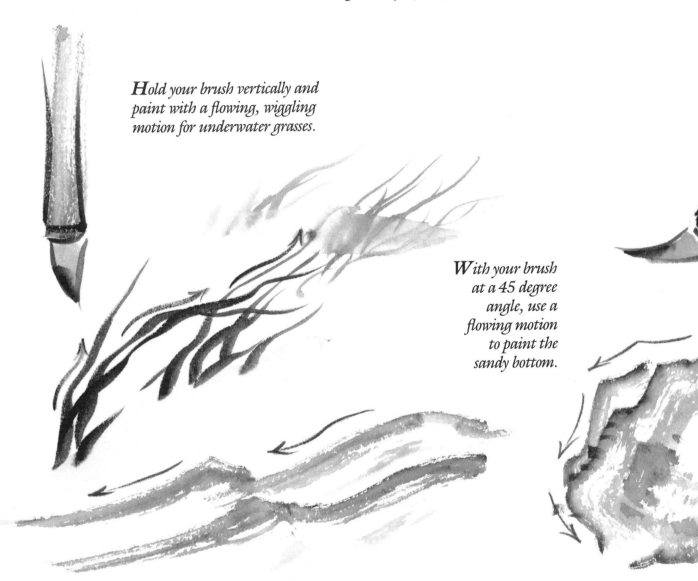

Hold your brush vertically and paint with a flowing, wiggling motion for underwater grasses.

With your brush at a 45 degree angle, use a flowing motion to paint the sandy bottom.

To paint a rock, keep your brush at a 45 degree angle. Now push your stroke against the bristles with an angular motion for the jagged edges.

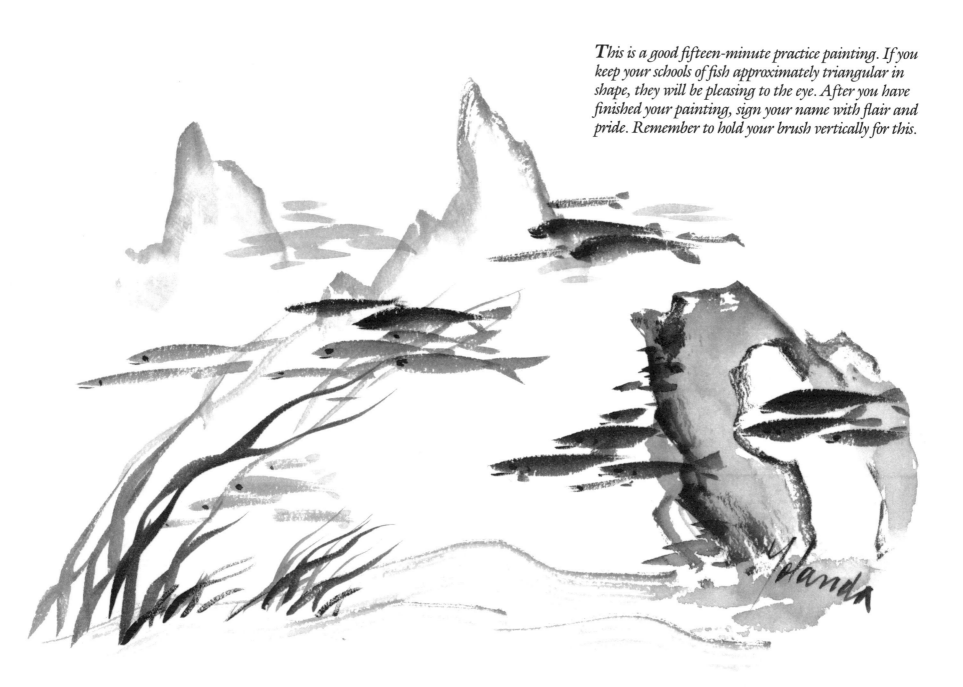

This is a good fifteen-minute practice painting. If you keep your schools of fish approximately triangular in shape, they will be pleasing to the eye. After you have finished your painting, sign your name with flair and pride. Remember to hold your brush vertically for this.

Water Lily

To paint a water lily, hold your brush vertically, load it with a gray wash, and accent both sides with black.

The water lily stroke is based on the wild orchid,

but the water lily petal is shaded on both sides, shorter, and fuller.

Practice adding petals for the opening bud.

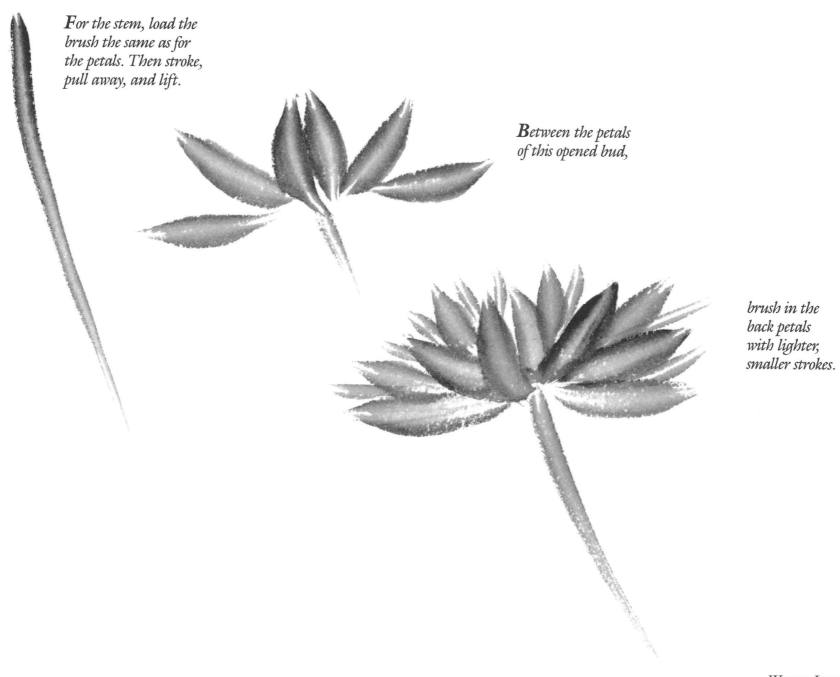

For the stem, load the brush the same as for the petals. Then stroke, pull away, and lift.

Between the petals of this opened bud,

brush in the back petals with lighter, smaller strokes.

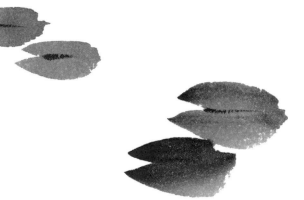

*Paint the
lily pad with
a vertical
brush, loaded
with a gray
wash but
tipped with
black.*

*Two bamboo leaves,
curved toward each
other, become a lily pad.*

*Practice them small, medium-size,
and large, with accents on the
pads in the foreground.*

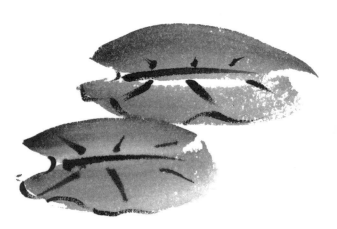

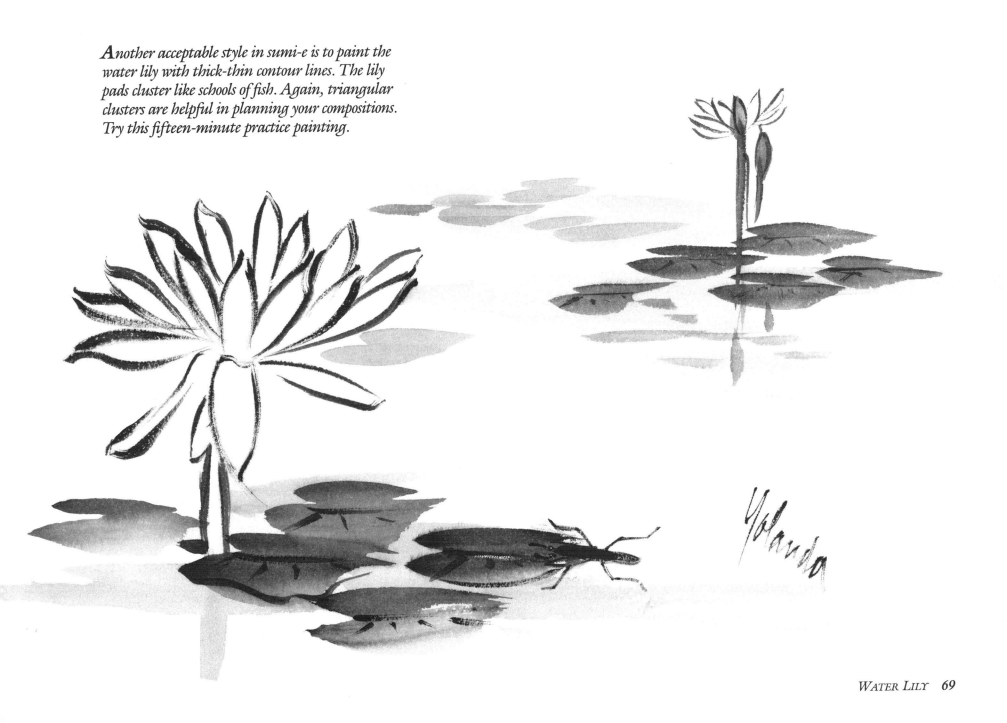

Another acceptable style in sumi-e is to paint the water lily with thick-thin contour lines. The lily pads cluster like schools of fish. Again, triangular clusters are helpful in planning your compositions. Try this fifteen-minute practice painting.

Yolanda

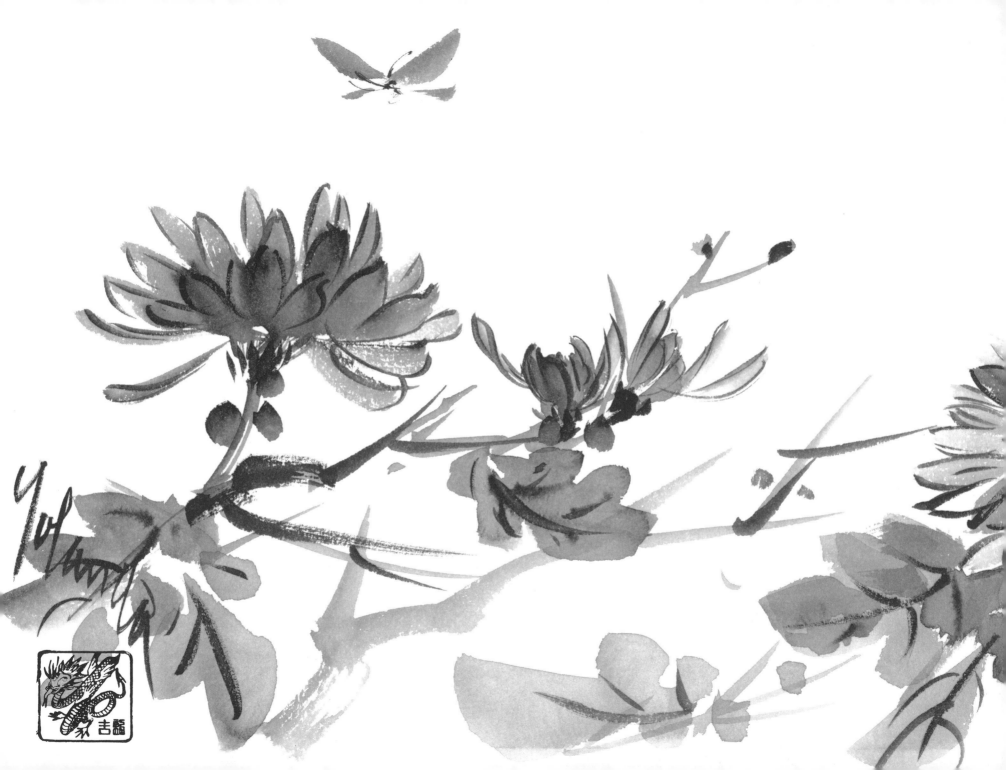

CHRYSANTHEMUM

The Chrysanthemum Brushstrokes

Chrysanthemums, the imperial symbol of Japan, are delicate, intricate, and hardy enough to bloom in the fall in spite of frost. You will need three strokes to paint them: one for the flowers, one for their angular stems, and one for the five-lobed leaves. The same strokes will enable you to paint several other kinds of spectacular flowers as well—and even mouse ears.

The Chrysanthemum Flower

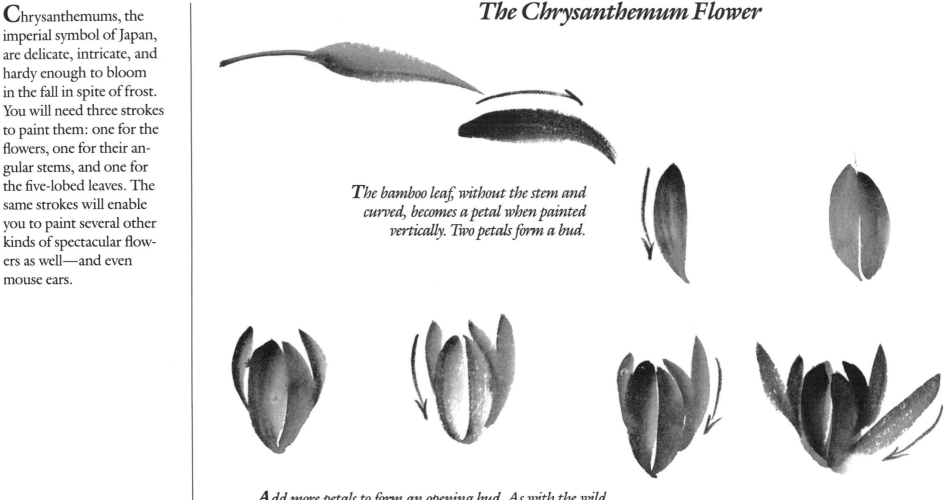

The bamboo leaf, without the stem and curved, becomes a petal when painted vertically. Two petals form a bud.

Add more petals to form an opening bud. As with the wild orchid, paint each petal from its tip to the center of the flower. Follow the arrows for the direction of petals.

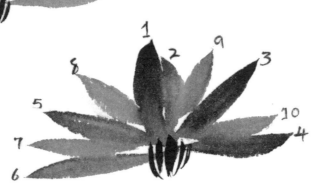

The numbers show the sequence of petals. Remember to paint them from tip to center of the flower! Arrange them freely in a wide semicircle, so that your flowers will be nice and full. Add more petals by filling in the spaces between the first set.

The calyx is visible in the half-view of the chrysanthemum. The stamens are shown in the full view by a group of short, dark strokes over a lighter wash.

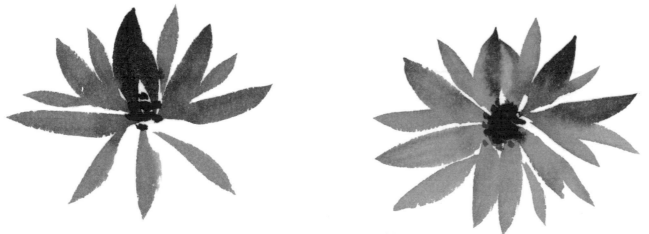

For a flower in full view, complete the circle by adding a few petals. Then fill in the spaces with broad, free strokes.

To paint a chrysanthemum with spoon-shaped petals, start with a standard chrysanthemum petal, press, lift up quickly, and pull away to paint a spoon-shaped petal instead. Remember to start your stroke at the tip of the petal and pull toward the center of the flower.

Arrange these petals into an opening bud, then into a bouquet of buds!

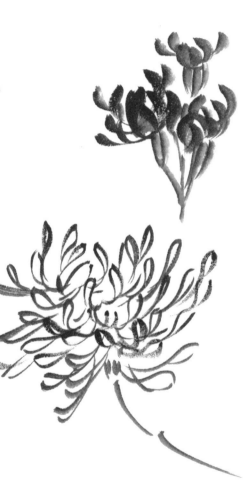

Now build the spoon-shaped petals into a lovely flower. You may also paint this kind of chrysanthemum with contour lines.

Here is another style of painting chrysanthemums where the petals are shown as round and flat. For this petal stroke, hold your brush at a 45 degree angle and push it down and around in a closed half-circle. Each stroke begins and ends near the center of the flower. Fill in the spaces between petals, working outward.

Finally, add a thick-thin accent line around each petal.

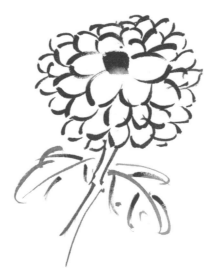

Once you've learned this style of chrysanthemum, you can also paint a similar flower completely with contour lines. Hold your brush vertically and paint with the tip for a good thick-thin stroke.

The Chrysanthemum Stem

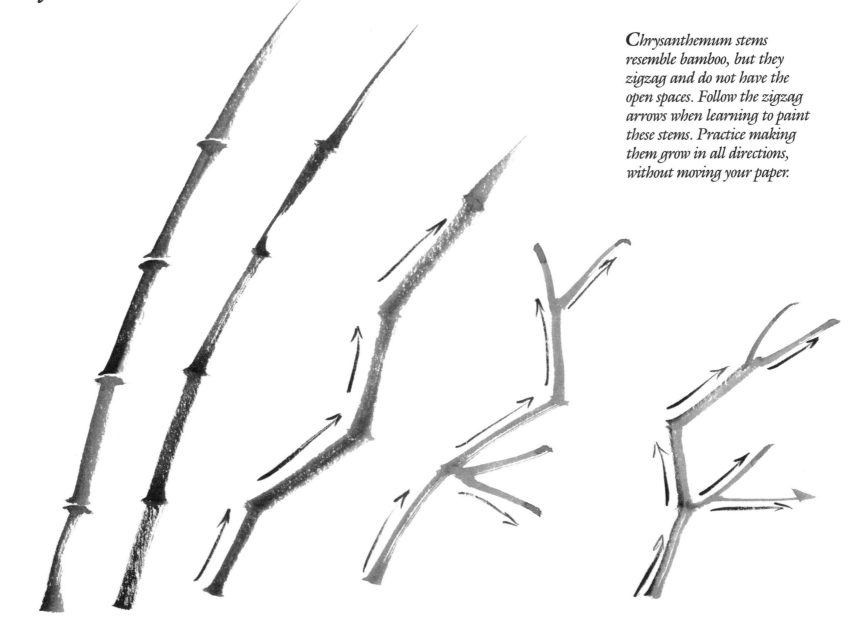

Chrysanthemum stems resemble bamboo, but they zigzag and do not have the open spaces. Follow the zigzag arrows when learning to paint these stems. Practice making them grow in all directions, without moving your paper.

The Chrysanthemum Leaf

*T*o paint a chrysanthemum leaf, start with a bamboo leaf. Now add four lobes, painted like flat chrysanthemum petals and ending toward the center of the leaf. When you put them all together, you have a five-lobed leaf. The veins can be added later.

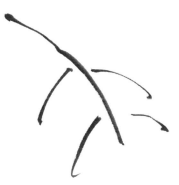

*S*ometimes, though, the leaf is painted over the veins with a light gray wash. Adding secondary veins afterward is a pleasing style.

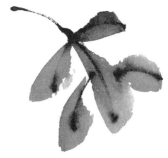

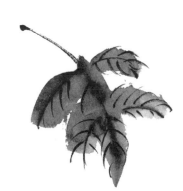

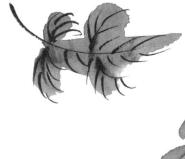

*L*earn to paint chrysanthemum leaves turning in all directions, without ever moving your paper.

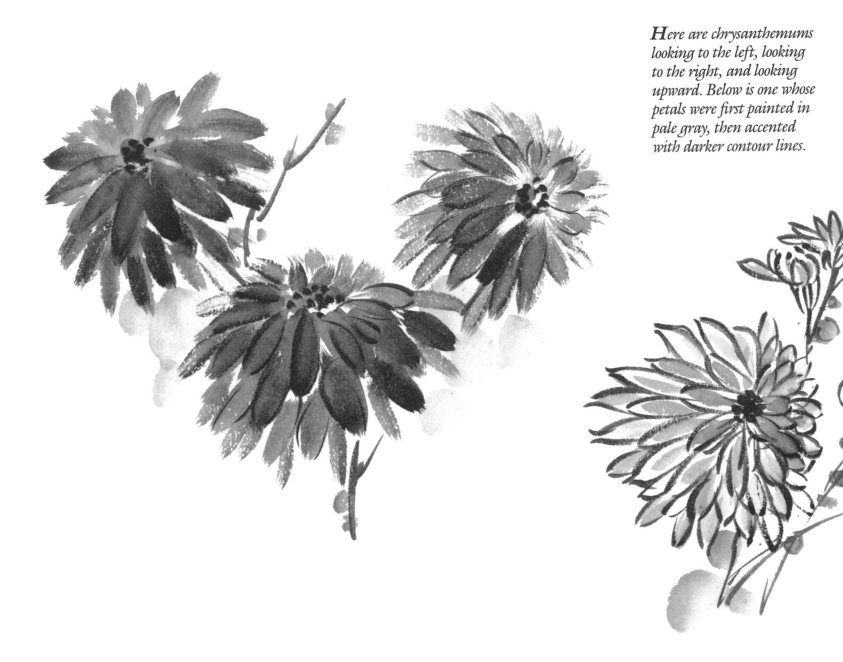

Here are chrysanthemums looking to the left, looking to the right, and looking upward. Below is one whose petals were first painted in pale gray, then accented with darker contour lines.

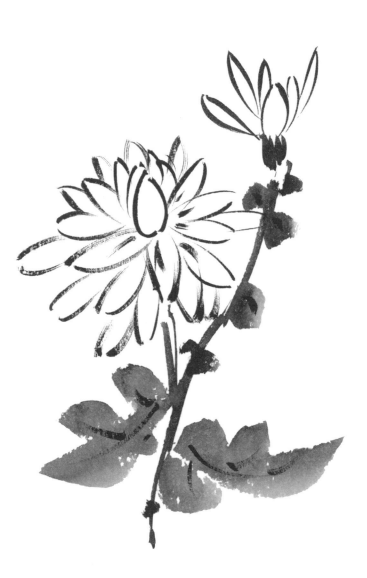

Here are contour-line chrysanthemums with full-stroke leaves, and vice versa. Both styles are enhanced by the striking contrast between flowers and leaves.

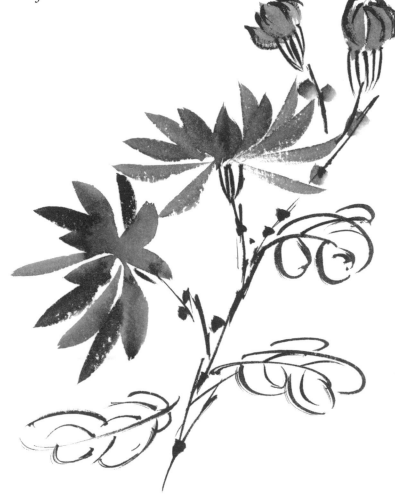

Related Strokes

Many kinds of flowers can be painted with the chrysanthemum strokes you have just learned. Let's start with the tiger lily—a flower that hardly looks like a chrysanthemum at all!

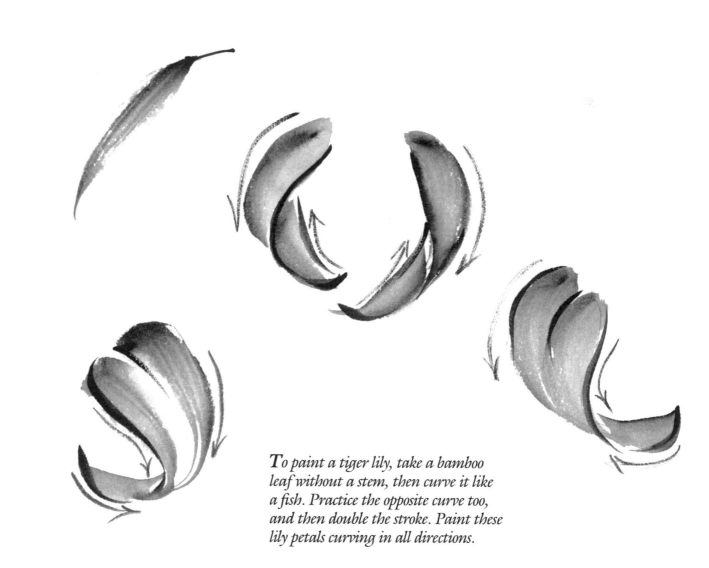

To paint a tiger lily, take a bamboo leaf without a stem, then curve it like a fish. Practice the opposite curve too, and then double the stroke. Paint these lily petals curving in all directions.

Combine two or three bamboo-leaf strokes, painted downward, for the lily bud.

The stamens are painted with dark accent lines. Press your brush tip flat against the paper for the pollen-covered tops.

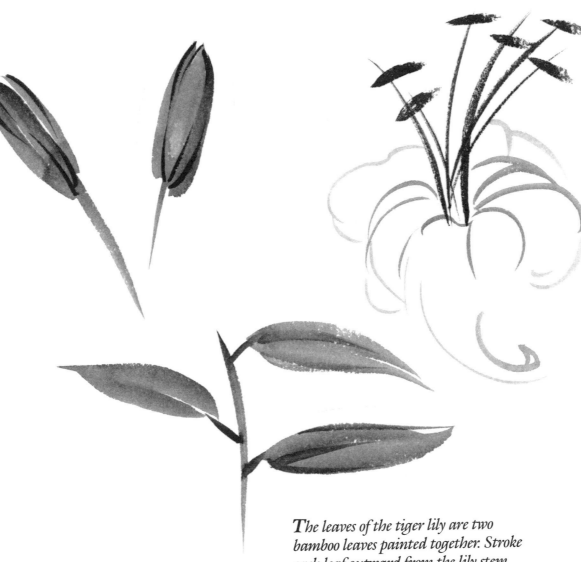

The leaves of the tiger lily are two bamboo leaves painted together. Stroke each leaf outward from the lily stem.

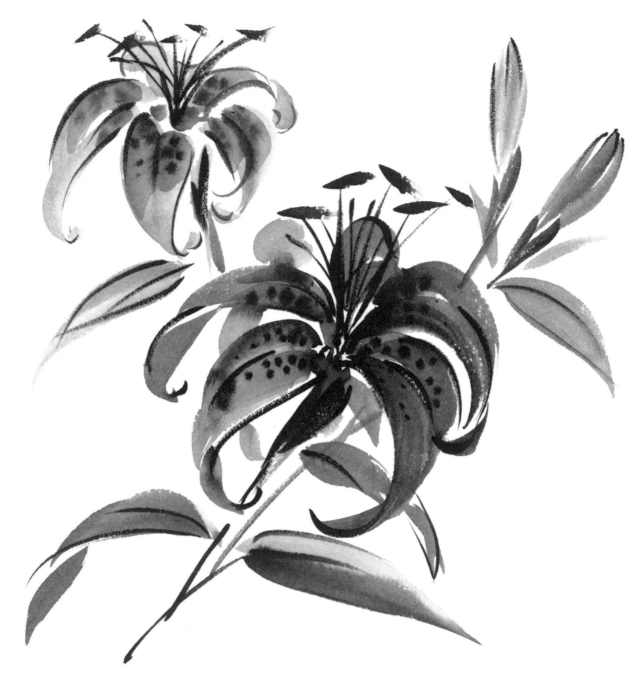

Now you are ready to put all these strokes together into an exciting painting. Start with the tiger lily's front petals and work around to the back. The spots on the petals are painted on a semiwet surface, using the tip of a brush that is loaded with black ink.

Camellia

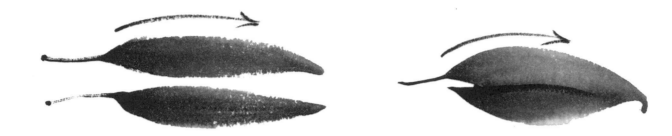

A camellia leaf is two bamboo leaves placed together.

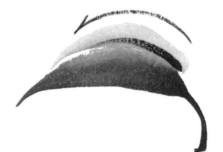

For a three-quarters view, paint a light gray stroke above a larger dark stroke. Practice this in the other direction too.

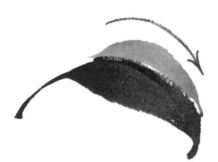

The curve of a leaf coming toward you hides its stem. Add the middle vein to all camellia leaves.

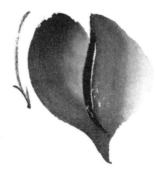

Take a light gray bamboo leaf without the stem, and practice curving it more and more.

Arrange five of these curved shapes in a circle to form the camellia flower, and use accent lines to bring out the petals.

The bud is painted with two accented strokes, both pulled downward. Leave the tip open.

Use tiny bird strokes to form the calyx.

Paint the delicate stamens with accent strokes.

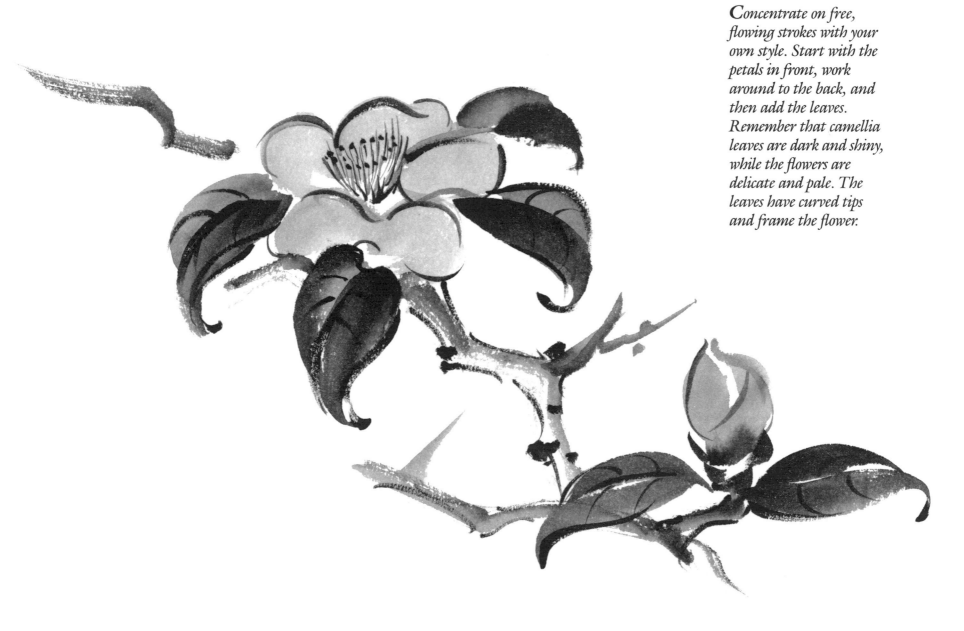

Concentrate on free, flowing strokes with your own style. Start with the petals in front, work around to the back, and then add the leaves. Remember that camellia leaves are dark and shiny, while the flowers are delicate and pale. The leaves have curved tips and frame the flower.

Poinsettia

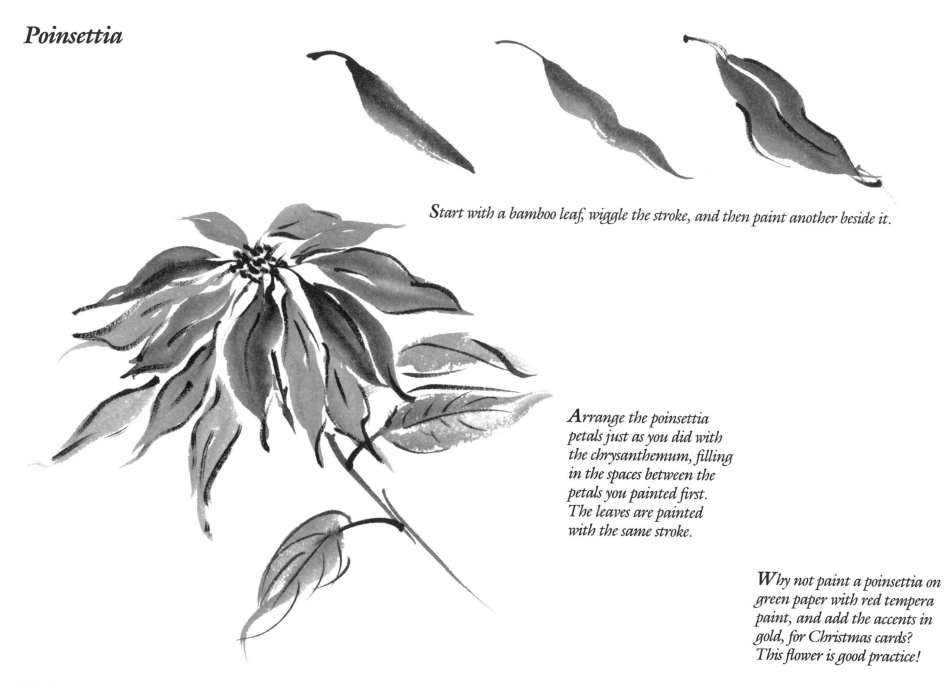

Start with a bamboo leaf, wiggle the stroke, and then paint another beside it.

Arrange the poinsettia petals just as you did with the chrysanthemum, filling in the spaces between the petals you painted first. The leaves are painted with the same stroke.

Why not paint a poinsettia on green paper with red tempera paint, and add the accents in gold, for Christmas cards? This flower is good practice!

Magnolia

Put all these strokes together to paint a magnolia flower. Start with either the front petals or the back petals. Use accent lines to help shape the petals, but leave the tips open. Practice loose, free strokes that express your own style.

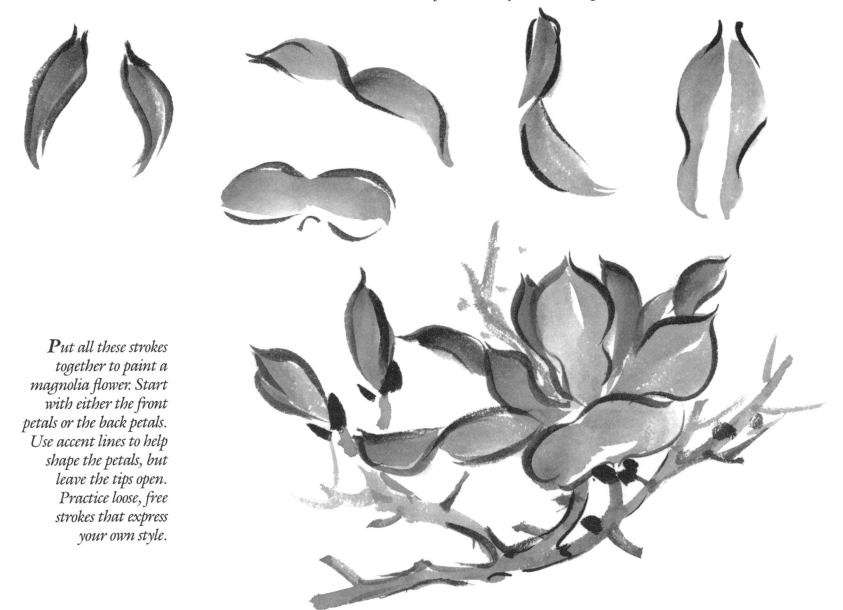

Mouse

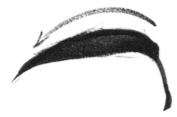

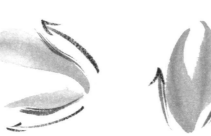

You can paint a mouse by using the chrysanthemum-petal stroke and others you have learned. Begin by holding your brush vertically. Two bamboo leaves, without a stem, make a mouse head turned sideways or facing you.

The chrysanthemum-petal stroke is used for mouse ears seen from different angles.

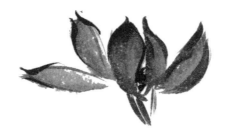

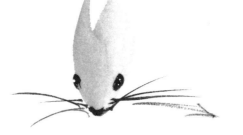

Use the tip of your brush to add the eyes, nose, and whiskers. Rotate the tip of the brush to block in the mouse's body.

Splay the bristles of your brush apart and lightly brush in the fur.

For the tail, load the brush with gray and tip it with black on both sides. Then pull it evenly and lift it away.

The mouse's thin legs are painted like a water lily stem. Then paint the tiny "fingers" with the tip of your brush, just like tiny bamboo twigs. Be sure to keep your brush straight!

Now you are all ready to paint a mouse! Start by blocking in the body, head, and ears. Then add the tail, fur, eyes, nose, paws, and accent lines wherever necessary.

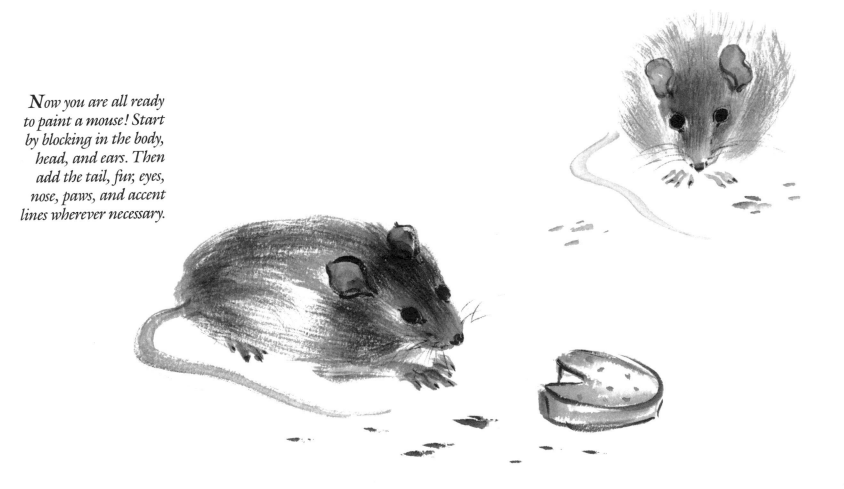

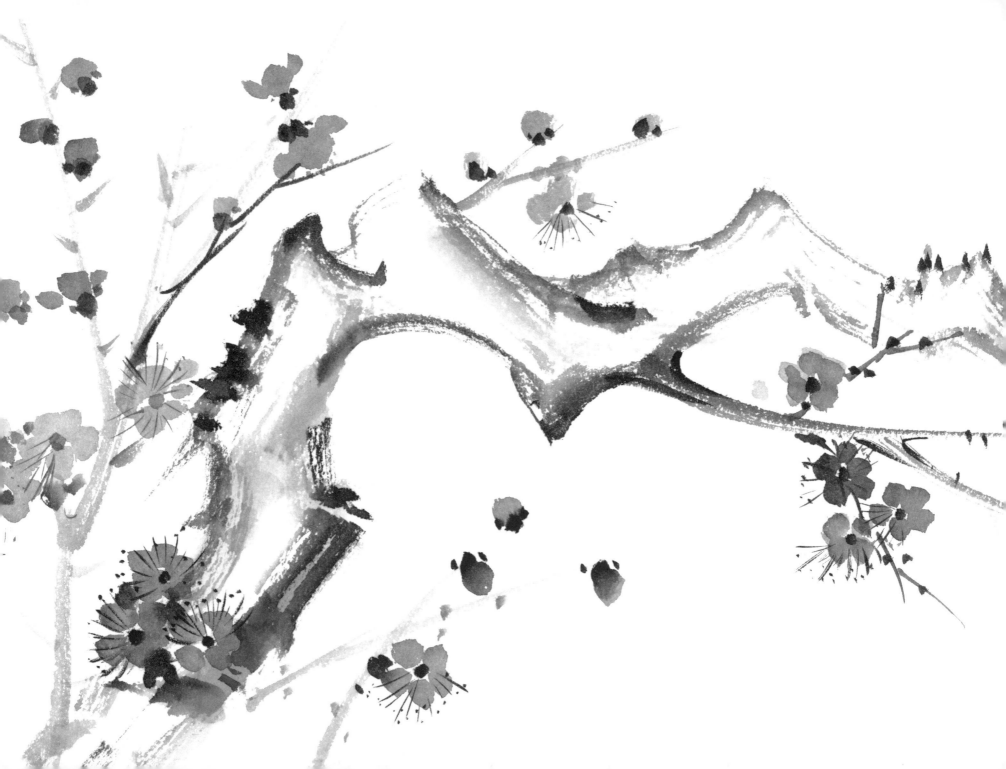

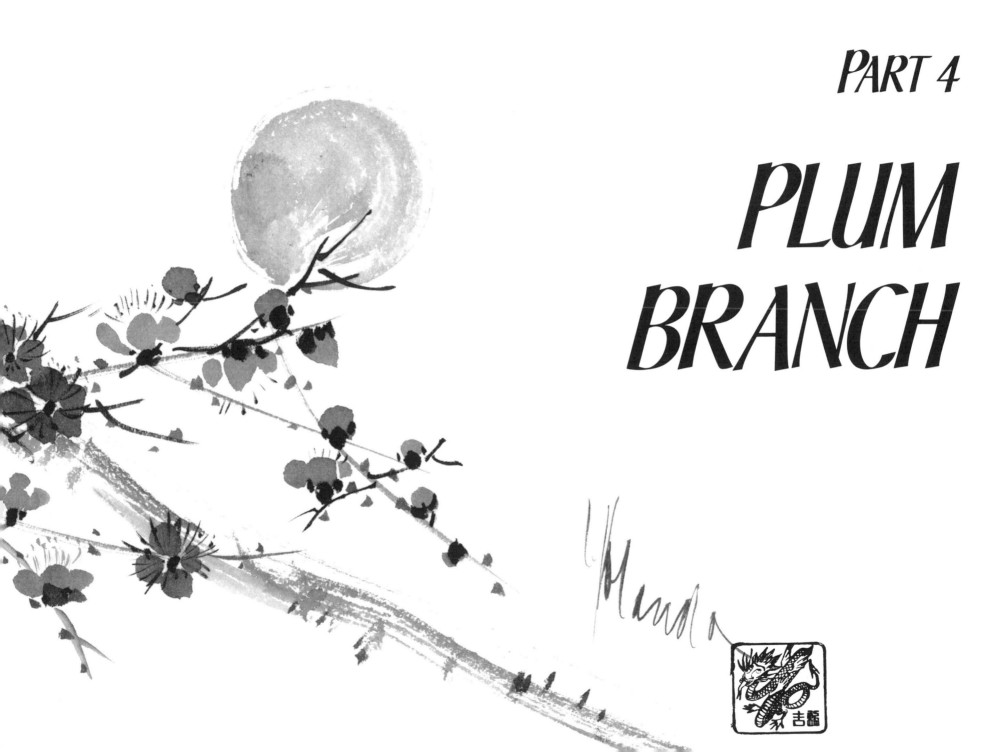

PART 4

PLUM BRANCH

The Plum Branch Brushstrokes

Plum trees are a paradoxical combination of fragile, sweet-scented blossoms and gnarled trunks. The strokes you will learn in painting the plum will help you paint other trees, and even rocks and mountains.

The Plum Blossom

Load the brush with a gray wash and tip it with black. Then, holding it at a 45 degree angle, push it around in a closed half-circle or C shape. (This is similar to the round, flat chrysanthemum petals on page 75.) Three plum petals plus the darker calyx complete the flower. The full blossoms have five petals, but they do not all show from every angle.

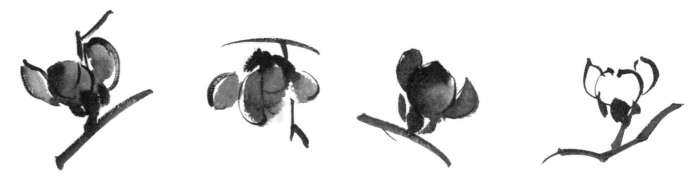

Learn to paint plum blossoms in all directions without turning your paper. You can also paint them with a thick-thin contour line.

Holding your brush straight, load just the tip with black paint. Now drag the tip across the paper to make delicate, thin lines.

Stroke the stamens from the outside in toward the center of the flower, in a circle. Use your whole arm for a steady stroke. (This stroke is also fine for mouse whiskers and pine needles.) The pollen is shown as dots at the ends of the stamens.

The stamens are visible when a plum blossom is facing the right, the left, or straight up or down. From the back, however, only the petals and calyx are visible.

The Plum Branch

It is important to show textures with your monochromatic ink. There are three basics:

Dry, light gray ink. For this texture, hold your brush vertically and pull it sideways so that the entire length of the bristles touches the paper.

Wet, medium gray ink. For this texture, hold your brush vertically and pull in the direction of the stroke.

Dry, black ink. For this texture, hold your brush so that only the tip touches the paper, and pull in the direction of the stroke.

Every plum tree has branches of different ages, and this is revealed by their contrasting textures. You might think of these types of branches as representing the three ages of people:

the grandparents stroke,

the parents stroke,

and the children stroke.

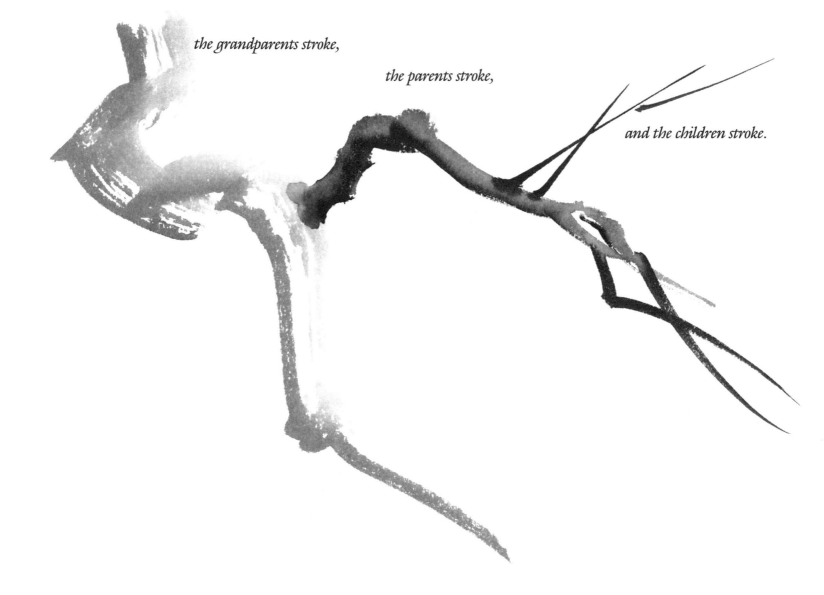

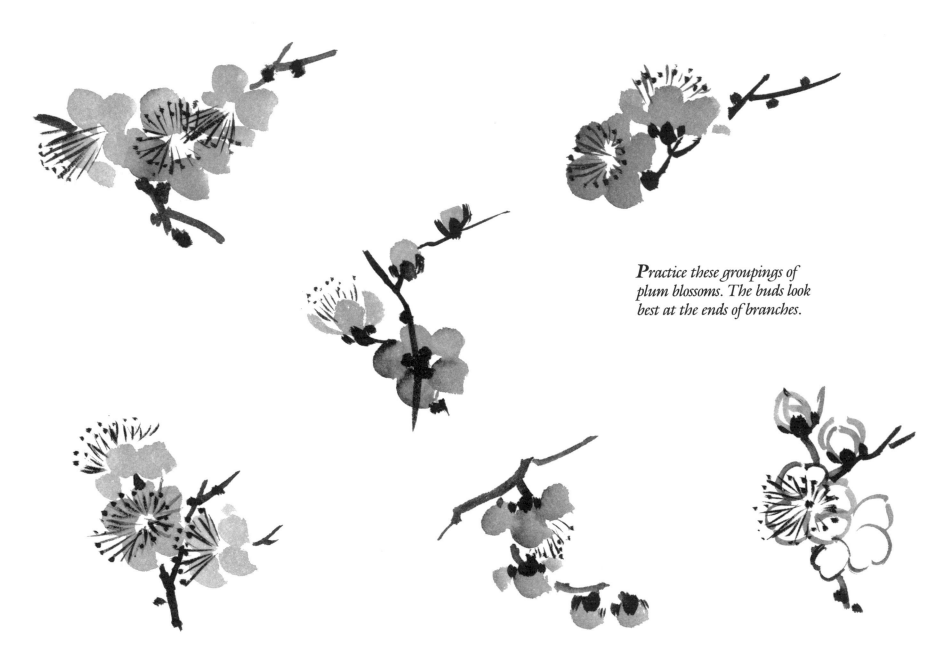

Practice these groupings of plum blossoms. The buds look best at the ends of branches.

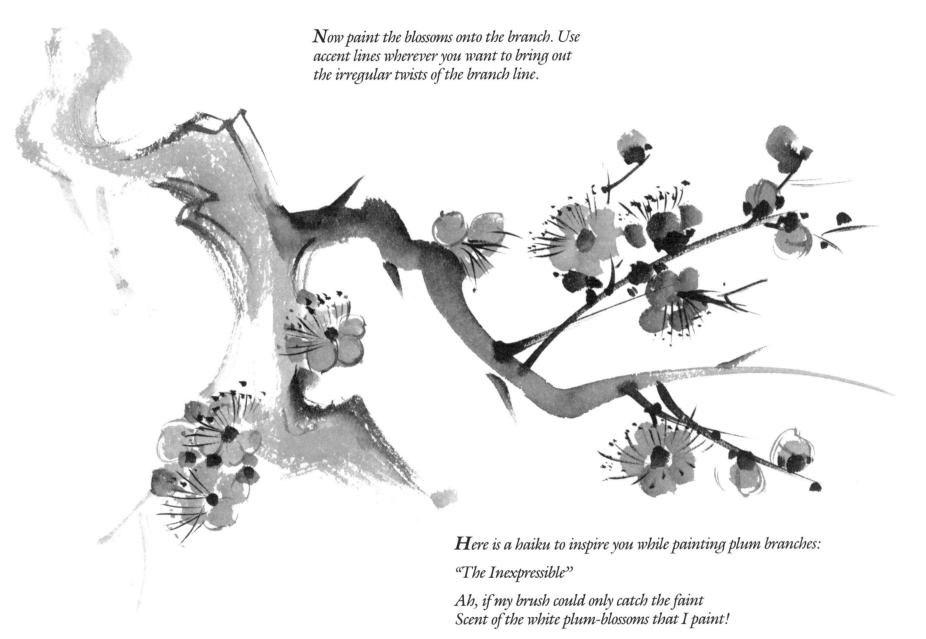

Now paint the blossoms onto the branch. Use accent lines wherever you want to bring out the irregular twists of the branch line.

Here is a haiku to inspire you while painting plum branches:

"The Inexpressible"

*Ah, if my brush could only catch the faint
Scent of the white plum-blossoms that I paint!*

Shôha

To paint gnarled trunks, load your brush with dry gray ink, and pull sideways to make flying whites for lots of texture. You may then accent your stroke with darker ink.

For knotholes, lay your brush flat. Then pull down, around, and up in the shape of a knothole.

Old trunks usually have interesting patches of lichen. To paint this, load the tip of your brush with black, and press it flat in irregular spots on semiwet paper.

The nailhead stroke is used to show new growth and thorns. First load the tip of your brush with dry black and press the tip flat against the paper (for the "head" of the nail). Then turn your brush perpendicular and pull it across and up, the way you did with wild orchid grasses.

Practice showing depth in your sumi-e paintings. The foreground tree is strongest in shade and detail. The background tree is smaller and lighter, and starts higher up on the paper. Try a whole tree using only gnarled trunk and nailhead strokes.

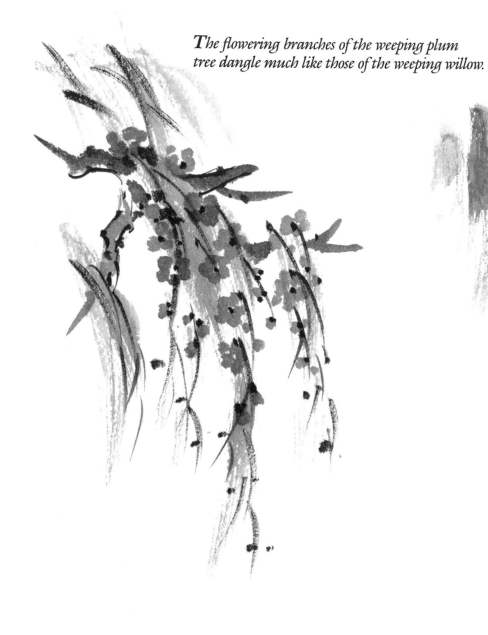

The flowering branches of the weeping plum tree dangle much like those of the weeping willow.

To paint this kind of plum, first block in the general shape with dry gray ink. Pull the brush sideways. Next paint the branches in.

Finally add the nailhead stroke cascading down. The blossoms are added last.

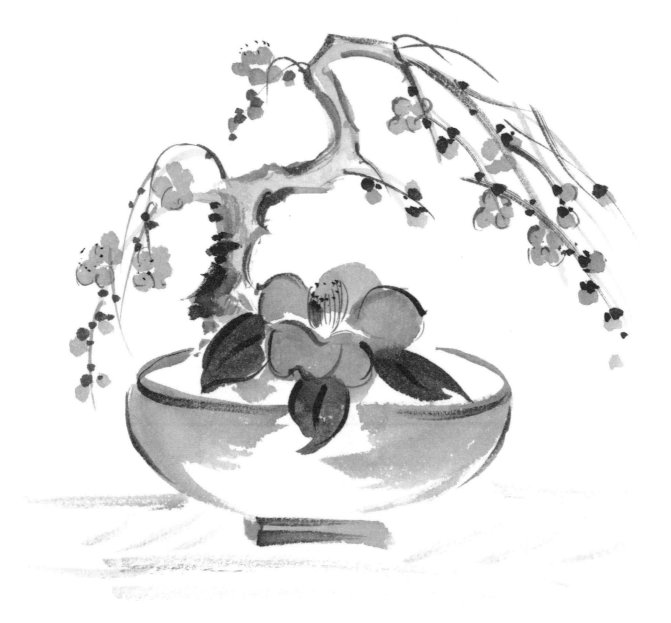

In Japan this ancient and traditional form of flower arranging is called ikebana. It is a way to bring outdoor beauty into people's homes. Many lovely paintings have been created from ikebana arrangements. Paint your own ikebana arrangement.

Related Strokes

The strokes you have just learned can be used to paint all kinds of trees, from pine trees to weeping willows to tiny bonsai trees in pots. You can also paint Mount Fuji!

Pine

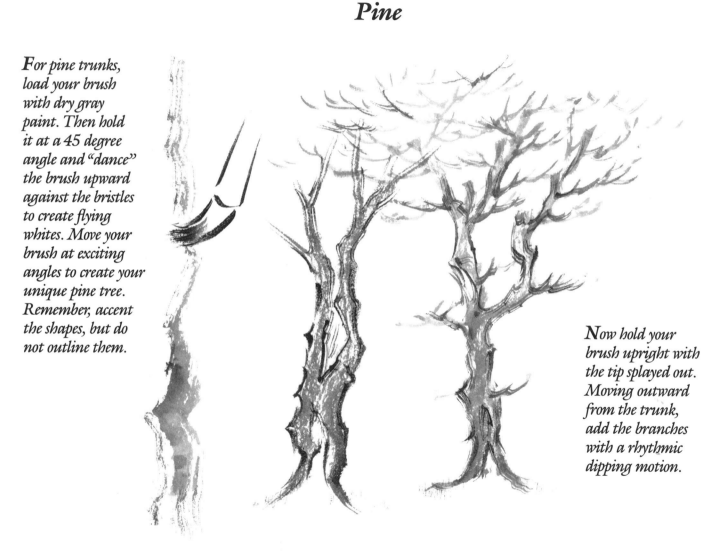

For pine trunks, load your brush with dry gray paint. Then hold it at a 45 degree angle and "dance" the brush upward against the bristles to create flying whites. Move your brush at exciting angles to create your unique pine tree. Remember, accent the shapes, but do not outline them.

Now hold your brush upright with the tip splayed out. Moving outward from the trunk, add the branches with a rhythmic dipping motion.

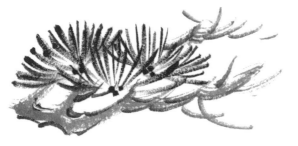

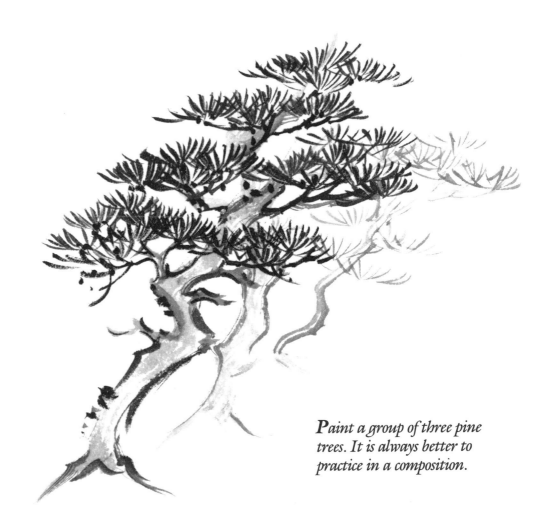

Paint a group of three pine trees. It is always better to practice in a composition.

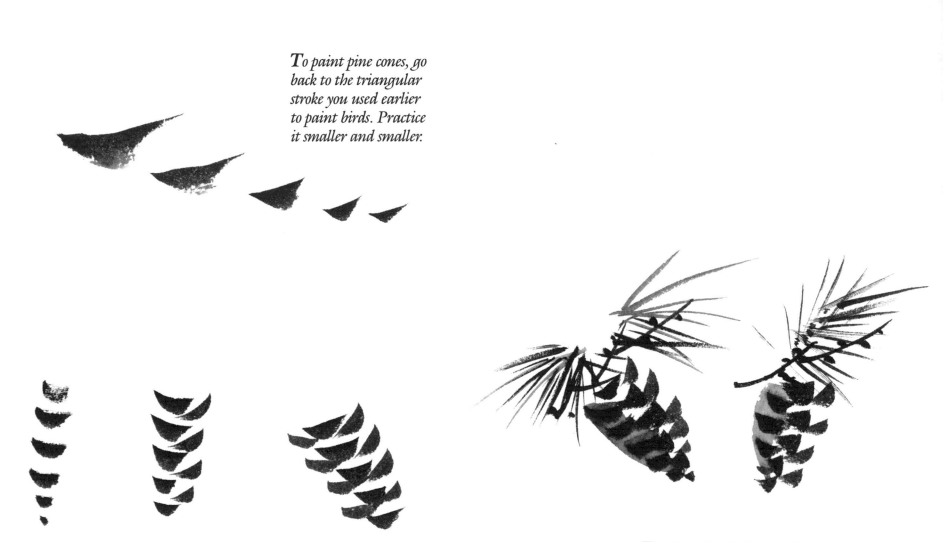

To paint pine cones, go back to the triangular stroke you used earlier to paint birds. Practice it smaller and smaller.

Finally add a lighter wash for shading, and pine needles.

Now paint a column of strokes that get gradually smaller toward the bottom. Fit in more strokes on either side.

Bonsai

A bonsai tree is a miniature tree that can be hundreds of years old. To paint its foliage, begin with the bamboo leaf without a stem.

This time, layer the strokes.

Then add the branches,

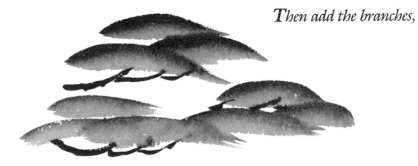

and finally the needles with a splayed brush.

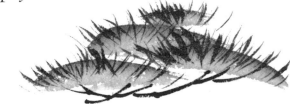

*H*ere's another method. Load your brush with gray and edge both sides with black. Now practice twisting and turning the brush in all directions to form a wonderfully bent bonsai tree. You can paint the trunk in **one stroke!**

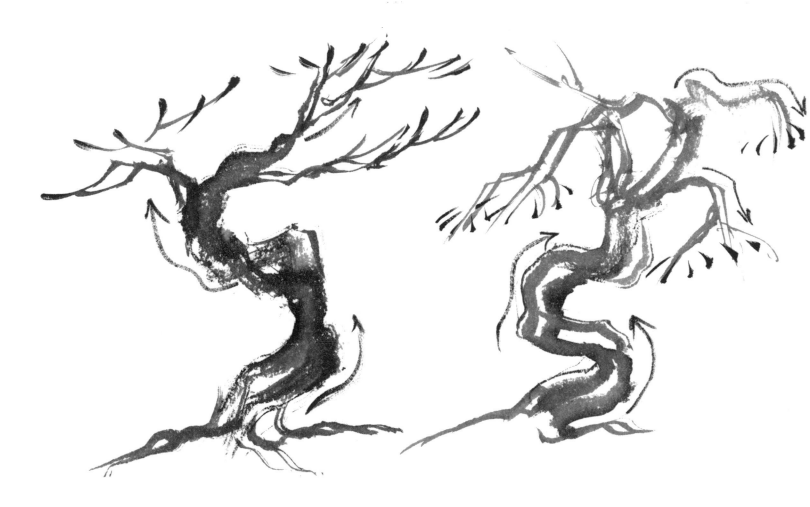

*U*se the tip of your brush for branches and roots. Some bonsai trees have branches growing upward; others have branches growing downward.

The roots of the bonsai ("tray tree") are clipped so that the tree becomes dwarfed and grows into an interesting shape. Bonsai trees are usually grown in pots, or sometimes in gardens. They are cared for from generation to generation.

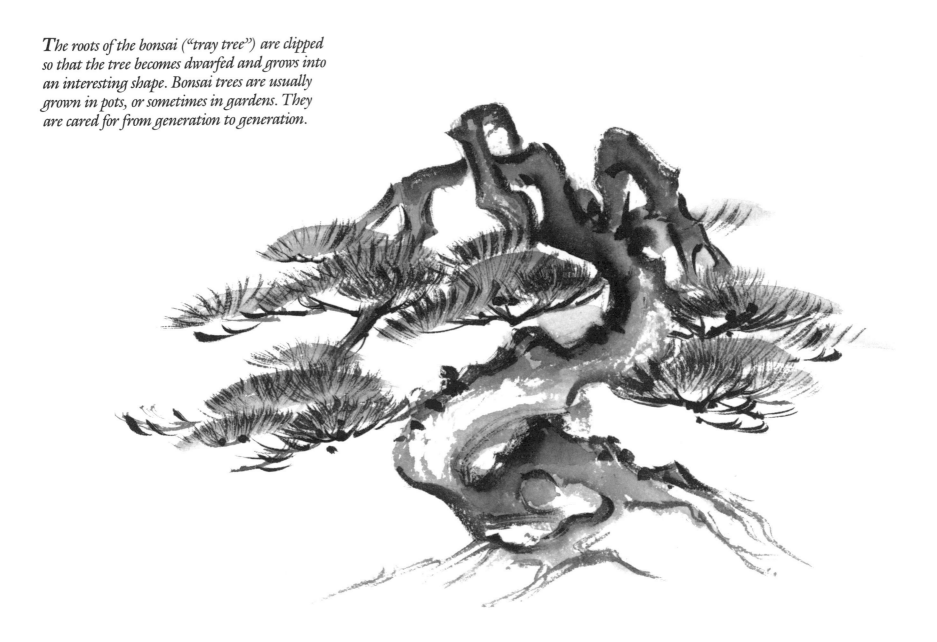

Weeping Willow

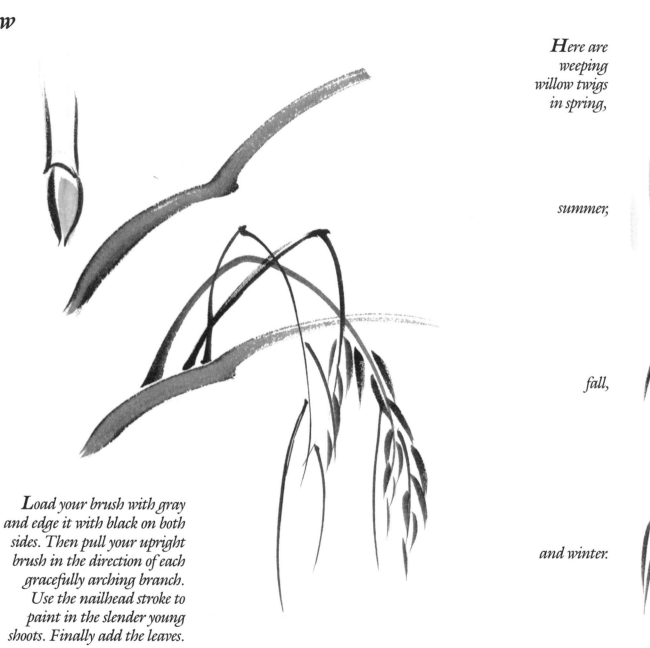

Here are weeping willow twigs in spring,

summer,

fall,

and winter.

Load your brush with gray and edge it with black on both sides. Then pull your upright brush in the direction of each gracefully arching branch. Use the nailhead stroke to paint in the slender young shoots. Finally add the leaves.

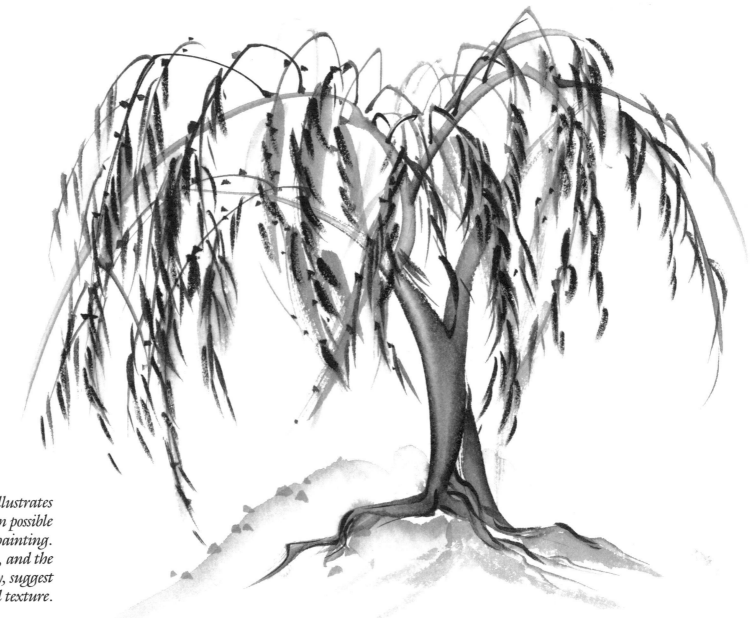

This weeping willow illustrates the range of expression possible in a monochromatic painting. The variety of strokes, and the many shades of gray, suggest both color and texture.

Rocks and Mountains

Sumi-e brushstrokes enable you to paint not only living things, such as various kinds of plants and animals, but also nonliving things like rocks and mountains. To paint a rock, load your brush with dry gray. Now lay the brush almost horizontally against the paper, and move around the edges of the rock.

Try different shapes. The flying whites are very important.

You may add an accent line to bring out the shape of the rock.

Or paint a rock or a mountain in one stroke, by loading your brush with gray and tipping it with black. Make sure you lay the tip where you want the top edge to be. These shapes could be boulders or mountains, depending on whether you add small plants or trees around them for perspective.

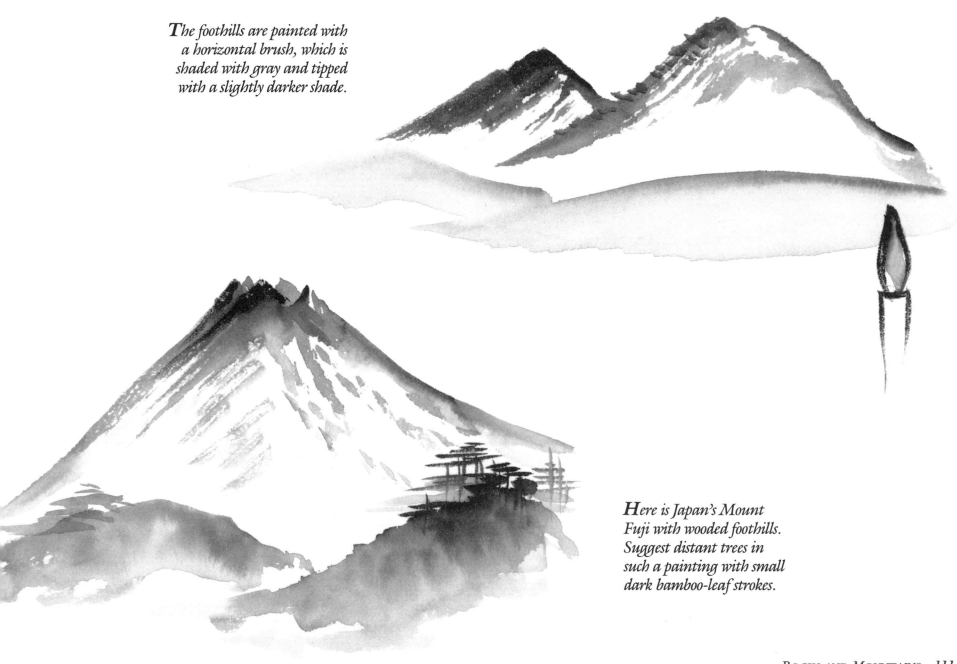

The foothills are painted with a horizontal brush, which is shaded with gray and tipped with a slightly darker shade.

Here is Japan's Mount Fuji with wooded foothills. Suggest distant trees in such a painting with small dark bamboo-leaf strokes.

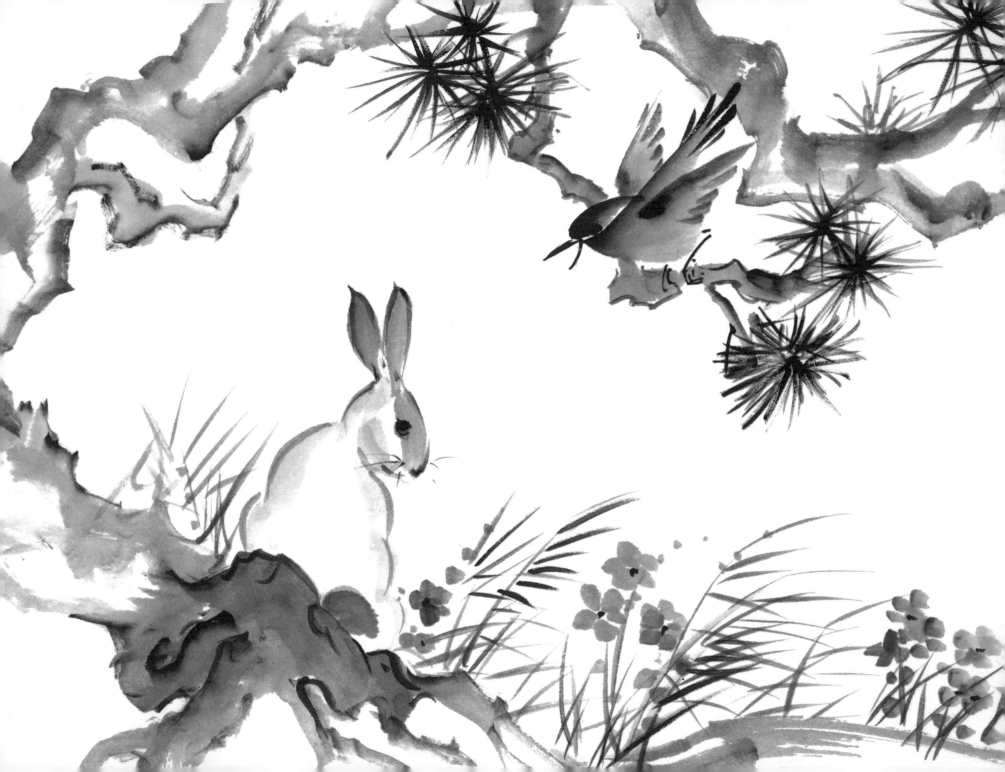

EXTRAS YOU WILL ENJOY

More Sumi-e Paintings

Now that you have learned the Four Gentlemen—bamboo, wild orchid, chrysanthemum, and plum branch—you are ready to try some sumi-e paintings that do not fit neatly into any of those four categories. Some are done with the press stroke, a beautifully simple way to paint certain flowers, leaves, birds, and insects. You will also learn to paint several more kinds of animals, ranging from timid rabbits to ferocious dragons!

The Press Stroke

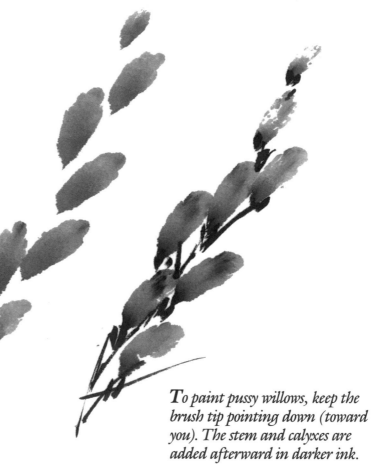

This stroke is not directly related to any of the Four Gentlemen but can be used to create some charming effects. First load your brush with a gray wash and tip it with black. Now, holding the handle straight up, press the whole length of the bristles flat against the paper. Rice paper works best for this stroke.

The press stroke is also useful for insects' wings.

To paint pussy willows, keep the brush tip pointing down (toward you). The stem and calyxes are added afterward in darker ink.

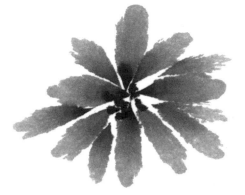

To paint flowers with the press stroke, point the tip of the brush toward the center as you paint each petal. Fill in between the existing petals, just as you did with chrysanthemums. Notice how the press stroke makes each petal darker toward the center of the flower.

In composition, let your flowers touch each other.

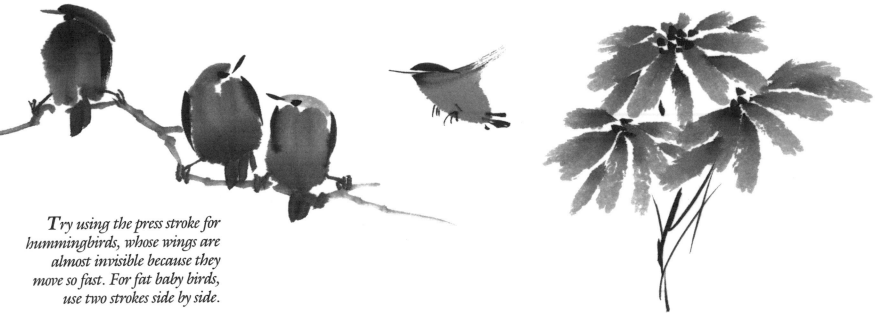

Try using the press stroke for hummingbirds, whose wings are almost invisible because they move so fast. For fat baby birds, use two strokes side by side.

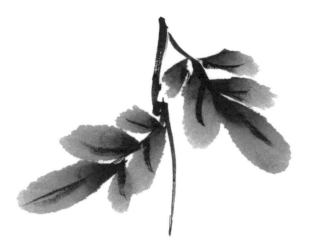

*Y*ou can also paint wonderful leaves with the press stroke. First practice the stroke with the tip pointing up. Add the other lobes, and finally the veins and stem.

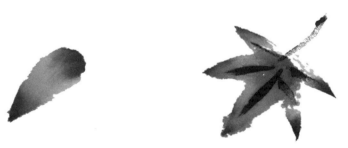

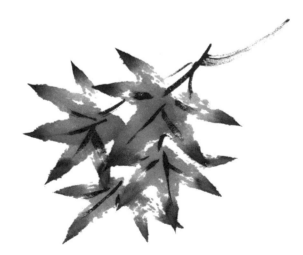

*N*ow practice the press stroke with the tip pointing down. Add the other lobes, with the round ends of the strokes overlapping in the center. Now group your leaves into a cluster and add the veins and stem. Notice how the flying whites make the leaves look glossy.

Rabbit

Learning to paint a rabbit will take some practice. Just remember to hold your brush straight and use a gray wash. Follow the order of the strokes:

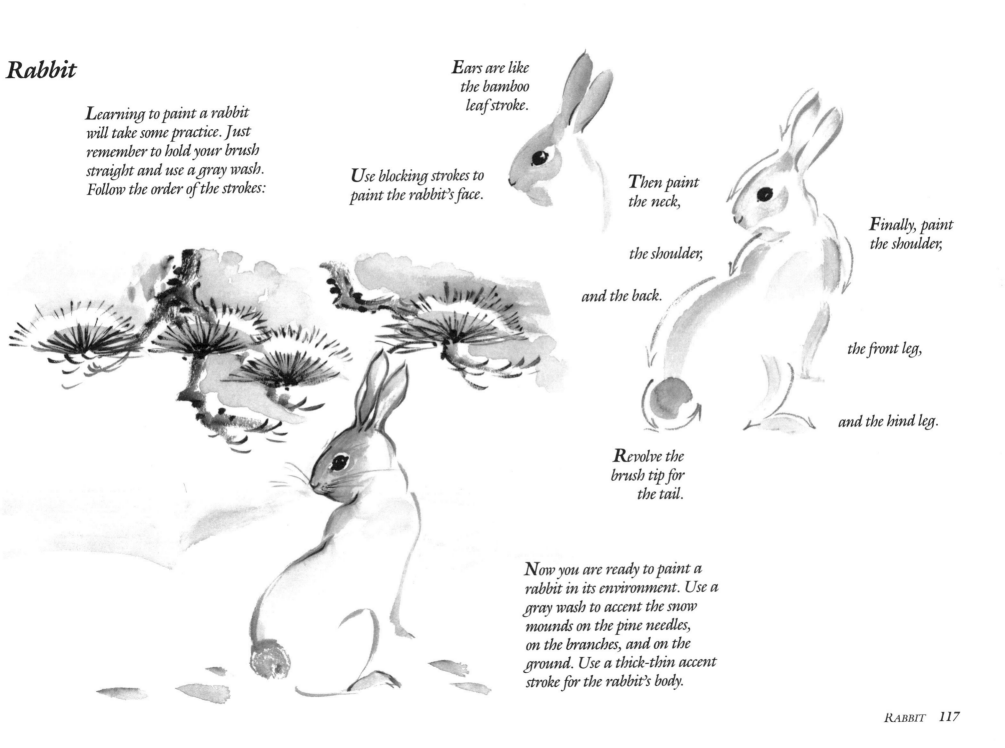

Ears are like the bamboo leaf stroke.

Use blocking strokes to paint the rabbit's face.

Then paint the neck,

the shoulder,

and the back.

Revolve the brush tip for the tail.

Finally, paint the shoulder,

the front leg,

and the hind leg.

Now you are ready to paint a rabbit in its environment. Use a gray wash to accent the snow mounds on the pine needles, on the branches, and on the ground. Use a thick-thin accent stroke for the rabbit's body.

Squirrel

Two bamboo leaves without stems help shape the squirrel's head. The plum blossom stroke forms his ears.

Here are details of the eyes, nose, and whiskers.

Splay out the bristles of your brush for the tail strokes. Remember that pine cones are painted with tiny bird strokes.

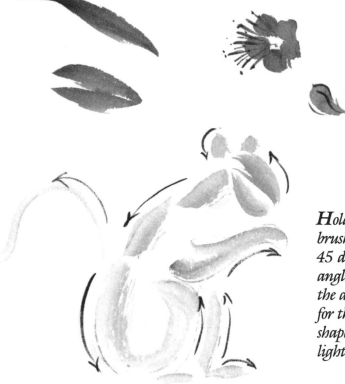

Holding the brush at a 45 degree angle, follow the arrows for the body shape. Use a light wash.

The squirrel's paws are painted with the bamboo-leaf stroke, and the claws are added with accent lines afterward.

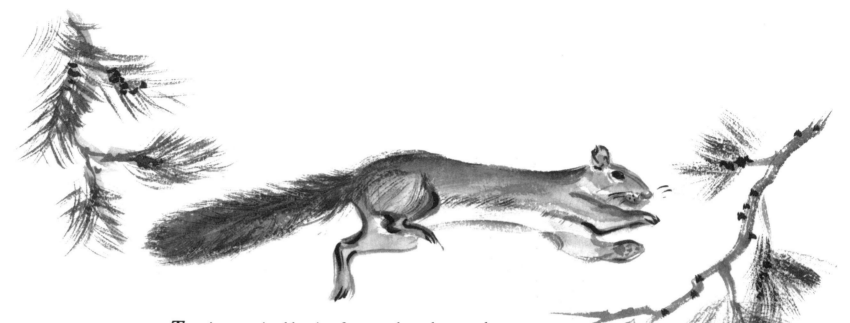

*To paint a squirrel leaping from one branch to another,
block in the strokes in this order and follow the arrows:*

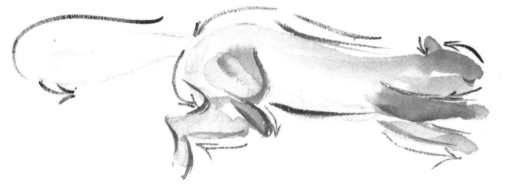

*two strokes for the head,
one for the back,
two for each hind leg,
one for each front leg,
and one for the tail.*

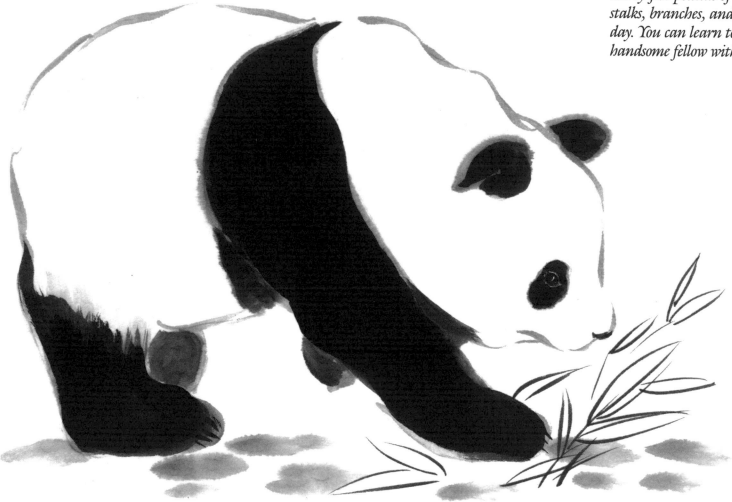

Bamboo is the panda's favorite food. The adult panda eats about thirty-five pounds of bamboo shoots, stalks, branches, and leaves every day. You can learn to paint this handsome fellow with sumi-e strokes.

The wild orchid leaf is the thick-thin stroke for the contour line of the panda's body.

His black ears and eye patches are painted with the plum blossom stroke.

The panda requires some drawing practice first. Block in the legs in gray, following the arrows for the shape. Then overlay with black ink for the finished animal. Sometimes rice paper gives a better effect for furry animals.

Dragon

The dragon is an ancient Oriental symbol. To paint one of your own, start with the bamboo-stalk stroke.

Block in the dragon's head with a light gray wash. Then paint a long body with lots of curves.

Be sure to hold your brush straight and pull against the bristles to create open spaces (flying whites).

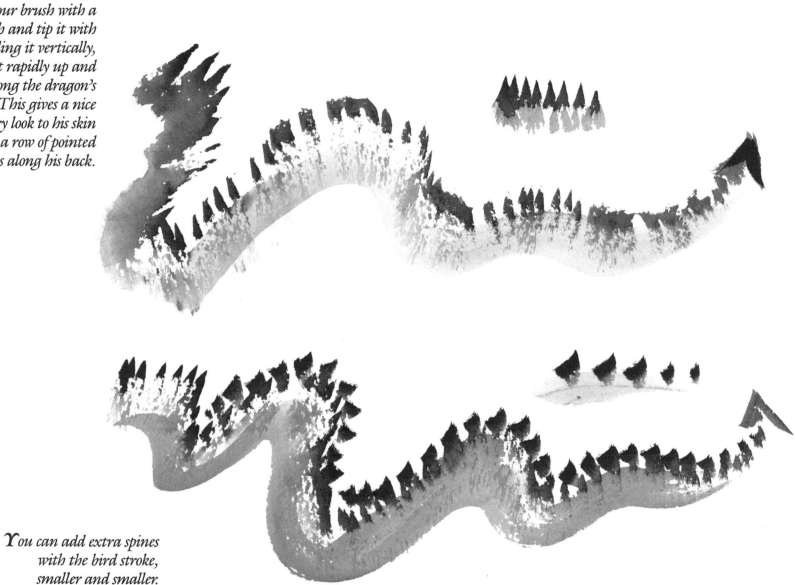

Now load your brush with a gray wash and tip it with black. Holding it vertically, bounce it rapidly up and down along the dragon's body. This gives a nice leathery look to his skin and a row of pointed spines along his back.

You can add extra spines with the bird stroke, smaller and smaller.

*H*old the brush at a 45 degree angle to paint the front and hind legs. Follow the arrows. The toes and claws are painted like bamboo twigs, using the tip of the brush.

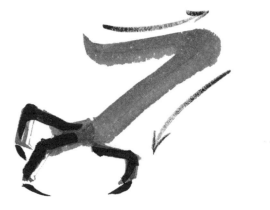

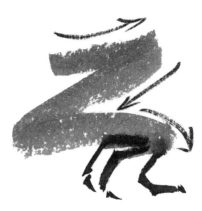

*U*se the chrysanthemum-petal stroke to paint the horns crowning the dragon's head. His long feelers are done with the wild orchid stroke.

*P*ull against the bristles with a sweeping stroke for his bad breath.

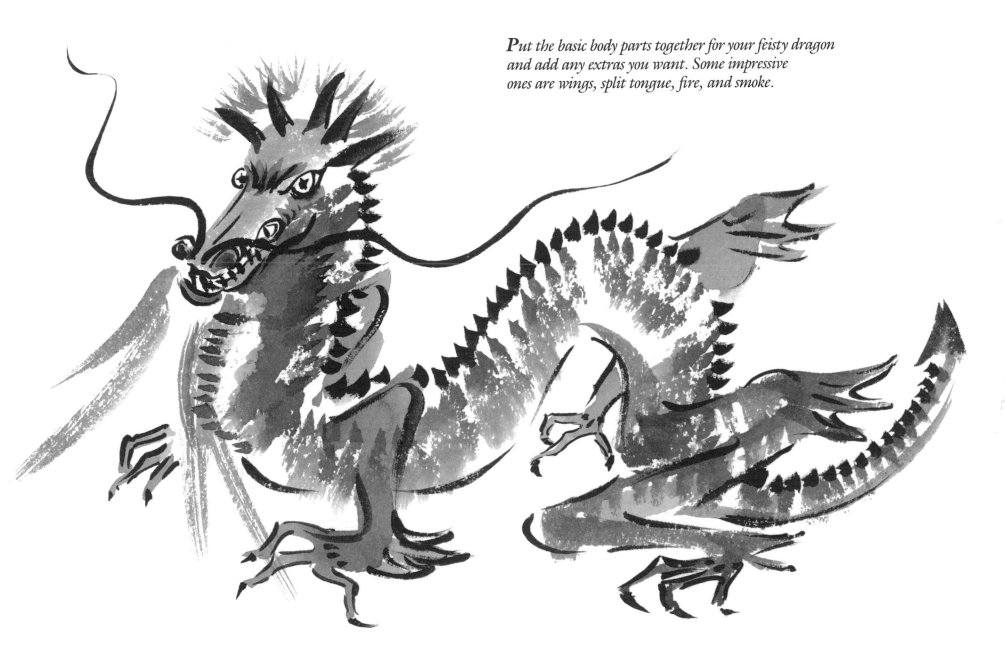

Put the basic body parts together for your feisty dragon and add any extras you want. Some impressive ones are wings, split tongue, fire, and smoke.

Glossary

accent line	A thick-thin stroke used to emphasize the important parts of a shape (but not to outline it). Darker accent lines are often added after most of the painting has been done in lighter ink. (*See also* contour line style).
action painting	Strokes that suggest movement.
bamboo-leaf stroke	A long, narrow stroke tapered at both ends.
bamboo-node stroke	A thick-thin accent line used to set off the joints of bamboo stalks.
bamboo-stalk stroke	A stroke shaded on both sides and lifted between segments.
bird stroke	A wedge-shaped stroke, based on the bamboo leaf, and used to paint birds, pine cones, and so on.
blocking strokes	Broad strokes in a light gray wash that help you plan a painting.
bonsai	A tree dwarfed in a pot or in the ground.
bristles	The hairs of a brush.
calligraphy	Beautiful writing.
calyx	The cuplike outer casing that holds a flower together and attaches it to its stem; usually visible only in side and back views of a flower.
chrysanthemum-flower stroke	A curved stroke used to paint petals of chrysanthemums and several other kinds of flowers.
chrysanthemum-leaf stroke	A stroke consisting of a bamboo leaf and four round lobes.
chrysanthemum-stem stroke	A zigzag stroke based on the bamboo stalk.
composition	The arrangement of separate images into an overall picture that is pleasing to the eye.
contour line style	A style of sumi-e in which shapes are partially outlined with thick-thin strokes rather than filled in. (*See also* accent line.)
"dancing" your brush	Using a dancing motion to paint a lively stroke.
flying whites	Open spaces within a painted stroke, left by drier parts of the brush, and important for many effects.
Four Gentlemen	The four basic categories of sumi-e brushstrokes: bamboo, wild orchid, chrysanthemum, and plum branch.
fude (foo-day)	A type of brush whose bristles are full and taper to a very fine point.
gnarled	Twisted, bumpy, and full of knotholes (as in a tree trunk).
hake (hah-kay)	A type of flat brush whose bristles taper to a fine edge.
hydrographic map	A map showing oceans, lakes, and rivers.
ikebana (ih-kay-bah-nah)	A Japanese style of flower arranging.
impressionistic	Giving an impression rather than a realistic view.
lichen (līken)	A tiny plant that grows in patches on rocks and tree trunks.
lobes	Sections of a leaf.
monochromatic	Using only one color. In sumi-e this usually means black and shades of gray.

nailhead stroke	A nail-shaped stroke, usually painted with black ink, to show young twigs and thorns.
palette	A surface for mixing paints. Palettes for sumi-e can be shaped like a saucer or like a cluster of shallow dishes joined together (called a chrysanthemum palette).
phoenix eye	The diamond-shaped space between crossed brushstrokes, such as bamboo stalks or wild orchid leaves.
plum-blossom stroke	A C-shaped stroke used to paint round petals, pandas' ears, and so on.
plum-branch stroke	A stroke that can be painted several ways to show tree trunks and branches of different textures. The brush may be pulled straight or sideways, with dark or lighter ink, to achieve specific effects.
press stroke	A stroke in which a shaded brush is pressed flat against the paper; used for flowers, insects, pussy willows, and so on.
rice paper	A type of paper made from the fibers of the rice plant. There are several kinds, including gashenshi, wagasen, and hosho.
rotate the brush	To turn an upright brush so that the bristles move in a small circle.
shaded brush	A brush whose bristles have been loaded with gray ink and accented with black (on the edges or on the tip, for example). Strokes painted this way create built-in shading to make objects look rounder or fuller.
splay the bristles	To spread out the hairs of a brush.
stamens	The tiny parts in the center of a flower that carry pollen. They are painted differently for various flowers.
sumi-e	Japanese for "ink picture." Also, the style of ink painting developed by the Japanese.
sumi ink	The ink traditionally used for sumi-e, made from soot, water, and glue.
sumi stick	Sumi ink compressed into a hard stick, which can be rubbed in water to make sumi ink.
suzuri (soo-zoo-ree)	A piece of slate against which the sumi stick is rubbed in water to make ink.
thick-thin stroke	A stroke that is thick, then thin, like the wild orchid leaf stroke and bamboo-node stroke.
topographic map	A map showing land features, such as mountains, deserts, and valleys.
veins	Accent lines within a painted leaf.
wash	Black ink (black watercolor works better for this) thinned with water to create different shades of gray.
wild orchid blossom stroke	A curved stroke used to paint tapering petals with rounded tips.
wild orchid leaf stroke	A long, curved stroke that tapers and widens to suggest twisting grasses or leaves.

Index

Accent line, 26, 35, 46, 51, 87, 110, 117

Bamboo brushstrokes
 leaf, 18–22
 node, 26–27
 stalk, 11, 23–25
Birds, 28–37, 115
Blocking strokes, 117, 119
Bonsai, 105–7
Brush(es)
 fude, 11
 hake, 11, 24, 25
 how to hold, 14
Brushstrokes
 blocking, 117, 119
 nailhead, 98, 100, 108
 press, 114–25
 thick-thin, 26, 48, 57, 69, 75, 92
 See also Bamboo brushstrokes;
 Chrysanthemum brushstrokes;
 Plum branch brushstrokes;
 Wild Orchid brushstrokes
Butterfly, 38–40

Camellia, 83–85
Cardinal, 34
Catfish, 63
Chicadee, 34
Chrysanthemum brushstrokes
 flower, 72–75, 78–79
 leaf, 77–79
 stem, 76
Contour line, 69, 75, 78, 79, 92

Depth, ways to show, 55, 99
Dragon, 122–25
Duck, 34

Fish, 60–65
Flowers
 camellia, 83–85
 chrysanthemum, 72–75
 ikebana arrangements of, 101
 magnolia, 87
 poinsettia, 86
 plum, 92–93, 96, 97, 100
 press-stroke, 115
 tiger lily, 80–82
 water lily, 66–71
 wild orchid, 56–59
Flying whites, 48, 102, 116, 122
Four Gentlemen, 8
Fude, 11

Grasshopper, 46

Haiku, 10, 97
Hake, 11, 24, 25
Hawk, 34
Heron, 36
Hummingbird, 34, 115

Ikebana, 101
Ink, sumi, 12, 94
Insects, 38–40, 44–46, 114

Ladybug, 46
Leaf
 bamboo, 18–22

chrysanthemum, 77–79
 press-stroke, 116
 wild orchid, 54–55
Lichen, 98
Lizard, 41

Magnolia, 87
Mountains, 110–11
Mouse, 88–89
Mushrooms, 47–49

Nailhead stroke, 98, 100, 108
Node, bamboo, 26–27

Orchid. See Wild orchid
 brushstrokes

Palette, 13
Panda, 120–21
Paper, types of, 12
Penguin, 37
People, 51
Phoenix eye, 58
Pine tree, 102–4
Plum branch brushstrokes
 blossom, 92–93, 96, 97
 branch, 94–101
 trunk, 98, 99
Poinsettia, 86
Praying mantis, 45
Press stroke, 114–25

Rabbit, 117
Rice paper, 12, 114
Rocks, 64, 110–11

Shaded brush, 15, 23, 24, 25, 61, 68, 92, 106, 108, 110, 111, 123
Shôha, haiku by, 10, 97
Spider, 42–43
Squirrel, 118–19
Sumi-e
 as companion to haiku, 10
 introduction of, into Japan, 8
 legends about, 8
 materials and supplies for, 11–13
 painting posture and position for, 14
 rules of, 15
 See also specific brushstrokes
Sumi ink, 12
Sumi stick, 12
Suzuri, 12
Swordfish, 63

Texture, 94, 95
Thick-thin stroke, 26, 48, 57, 69, 75, 92
Tiger lily, 80–82

Walking stick, 44
Water bowl, 13
Watercolor, 12
Water lily, 66–71
Weeping willow, 108–9
Wild orchid brushstrokes
 blossom, 56–59
 leaf, 54–55